THE VIDEOBIZ

A Practical Guide for Video Startups

Brien Lee

Copyright © 2019 Brien Lee

All rights reserved.

ISBN: 9781795343725

Dedicated to my family, mentors, clients, talented co-workers, employees and suppliers, all of whom helped me make it through 40 years of learning, creating, teaching and more successes than failures.

FORWARD ... 1
 Foreword: Who Am I, Really? 1
MINDSET .. 4
 Chapter One .. 5
 Chapter Two .. 10
 Chapter Three ... 15
THE BASICS ... 18
 Chapter Four ... 19
 Chapter Five ... 22
 Chapter Six .. 35
 Chapter Seven .. 42
 Chapter Eight ... 55
 Chapter Nine .. 67
 Chapter Ten ... 81
YOUR BUSINESS MATURES 86
 Chapter Eleven ... 87
 Chapter Twelve ... 93
 Chapter Thirteen ... 99
FINAL ADVICE ... 108
 Chapter Fourteen ... 109
SUPPLEMENTAL MATERIALS 116
AFTERWORD .. 137

FORWARD

I think of myself as a writer and editor. But movies and music shaped my childhood.

You see, I was born with big ears.

My first eight years featured the sounds of New York City. At the corner of 179th and Broadway, we were entertained by a symphony of buses and trucks turning from Broadway onto 179th, up the few short blocks to the George Washington Bridge and westward toward New Jersey. Occasionally, one didn't quite make the turn, which led to a great visual show outside of our second story windows.

I loved music and records. I remember jingles and opening narrations and am moved by movie soundtrack music. I can sing you the (wordless) theme music to almost any radio program from the 1950s, even soap operas and game shows.

But it wasn't just audio. The TV was on all the time, and I started watching old movies, in addition of course, to *Howdy Doody, The*

Mickey Mouse Club, *Superman*, and the *Three Stooges*. Plus, my mother's soap operas and my father's weekly *The Honeymooners*.

And slides: my father loved photography and he adopted slides as his medium. He'd take family gathering pictures, get them developed, and then warm up the slide projector for a narrated "show."

When I was five my ears were operated on to remove growths from behind them that made them stick out. It was successful. I lost a little treble but I gained a bit of self-confidence.

I recuperated in my parents' room listening to the radio. No, not rock and roll, but radio soaps, Bob and Ray (the comedy duo), and *Make Believe Ballroom*.

Two years later I was in the hospital and then recovering from rheumatic fever. Recovery was at a place called "Mary Harkness" in Port Chester, New York. I was there for four months. When I got some kind of bug, they took me out of the ward of 20 kids and put me in a private room. It was there in that private room that I learned how to read: Whitman cowboy novels about Roy Rogers, Gene Autry, and Lassie and Jeff. Real books, with big type but a fair number of pages, and no pictures. The skill I learned in that room helped me throughout my life.

So long to the city: after that, my parents decided it was time for the suburbs. Other folks were doing it, including our family friends the Banks's and the Fallons.

We landed in East Brunswick, New Jersey, Exit 9.

THE VIDEOBIZ

There I discovered rock and roll radio, hi-fi, "old time" radio shows being rebroadcast on FM (they didn't even know what to do with FM at the time), as well as the joys of the great outdoors. I had freedom thanks to my JC Higgins bicycle, given to me after my mother ran over my favorite trike.

But my big breakthrough was buying a small tape recorder for $25 that used 3-inch reels and no capstan, which meant it never played back at the same speed twice. I started recording radio, including rock and roll radio (WABC, WMCA), baseball games, and things off of the TV that I assumed would never be heard again. (I was wrong about that one.) But with the playback only as good as four C batteries, there was only so much I could do. That is, until my dad brought home a Sony TC-101 from Willoughby's, around the corner from his office on Fifth Avenue. This was a mono recorder that came with a good microphone, and it was off to the recording races.

Now it was sound effects, and natural sound. I'd record my family surreptitiously, interview my grandfather pretending to be Met's manager Casey Stengel, family sing alongs, and the popular DJs and their music. Soon my friends and I were recording ad-lib take-offs TV shows or classroom events.

By the time I went to college in Milwaukee I had a stereo recorder, and I dutifully recorded my favorite Beatles, Beach Boys and Association records on it, plus off-air recordings of WABC-FM (in stereo) since those records weren't going to make the thousand-mile trip. We used that recorder to make "tribute" birthday party tapes for college friends, singing new lyrics to Beach Boys songs featured on *Stack-o-Tracks*, an album of Brian Wilson backing tracks to some of their most popular songs. Another time, I threw together

a religious documentary to persuade a nun to give me a C in theology (I otherwise had missed far too many classes).

My major was journalism (writing), my minor was broadcasting. I was co-editor of the yearbook and for two years in a row I created documentary audio productions that were distributed as flexodisc records with the yearbooks.

The culmination of all of this was that I started doing slideshows for our year-end publications banquets, enlisting talented photographers to take pictures in and around the j-school of all the people that worked and attended there, in all of their class, extracurricular and social activities. Once I had maybe a couple of hundred slides, I would lay those slides out into a story, load up two trays and a "dissolve unit" (which allowed the slides to fade into each other on the screen), and time the whole thing to a soundtrack I created.

The year I graduated, one of those photographers and I started a business— a slide show business. We did it all: write, shoot, create soundtracks, edit the visuals and time them to the soundtrack. The shows and equipment got more sophisticated and the productions bigger. This eventually led to film, video, large meetings, speaker slides, big multiscreen extravaganzas and quite a lot of business theater as well. We wrote music, lyrics, directed casts, whatever it took.

And I did that stuff for forty years.

That's my story. Now yours.

MINDSET

CHAPTER ONE
Who Are You, Really?

Stress Warning!

Depending on your intent, making videos can be stressful. What do I mean by intent? Well, intent is how well you plan on producing your work, and whether you plan to charge money for it and meet deadlines. While this book does have some business-to-business sections, the greater emphasis is on the creative process in general. Even if you are making videos for your own edification, for documentaries or for festivals, you will have to meet your own standards and those of your eventual audience. Stress comes from the constant effort to meet and exceed stated goals, either our own or our clients'. If you don't feel some stress in the production process, you may have a focus problem—on a deadline, on client expectation, or your own sense of self-worth.

Knowing your Strengths

The key to success in the video biz is knowing your strength. There are many aspects to the video biz, and most (but not all) of them are creative. Are you a writer? A shooter? A planner? An organizer? Or do you just relish building and sustaining a viable communications business?

Whether you are just starting out or are an experienced hand, something will call to you— some aspect of this audio-visual world will call to you.

My calling, as I previously described, was 35 mm slides and movies and TV. But that really doesn't describe what really turned me on.

It was the music. I was fascinated by the music used in old TV shows like *Fury*, *Superman*, *Highway Patrol*, *Sea Hunt* and others. What I didn't realize was that the music used in these shows was not made for them. They were selections of "library music"—

THE VIDEOBIZ

professionally produced music cues that could be leased for use in TV programs and industrial films.

Combined with my love for TV themes, later variations on those themes, and network IDs and jingles, this led to a strength that would eventually form the basis for my entire career, far surpassing just soundtracks or music selection!

My other strength was writing. In fact, when I graduated college I had to choose between a solid offer from a major newspaper and starting the slide-show business from scratch. I knew my writing ability and music chops would serve me well. I knew my strength.

Knowing Your Weaknesses

We all have weaknesses. For this discussion we only need to discuss those things you're not so great at in the video game.

For all my love of things visual, making visuals—photography, art, text—this was never my strength.

I knew that.

Which is why for my college slide shows I partnered up with a couple of great photographers, one of whom would later become my business partner.

These photographers had what I didn't: an uncanny ability to see things and shoot things differently. They could tell stories through pictures and, because of their college courses, knew how to tell a film picture story to add pizazz to what might have been a drab slide show.

THE VIDEOBIZ

I could add music and pacing, and words if necessary.

The idea of knowing your weaknesses is not to discover something you're bad at, but something you're just adequate at and have no desire to improve. Two strengths in the form of two people is quite an improvement over one strength and a bunch of mediocre ones.

And there's always room to learn and improve other areas as you grow.

Extrovert or Introvert?

Unless you plan on writing grant requests for the rest of your life, somebody is going to have to pay for this "hobby" of yours. Whether you're producing corporate work, museum pieces, family tributes, documentaries or even sports documentation, you're only as good as your *next* job. That's because once the current job ends, the money runs out and you don't have any cash flow until the next job starts.

Creative people come in many flavors. But basically, there are two types for this chapter: introverts and extroverts.

I'm an introvert. I create in my head, don't talk about my ideas, do my work and surprise everyone when it's done. I am also shy around people I don't know. I'm the kind of guy who needs an agent, but for most of us starting out, this is a non-starter. Hell, we may not even have finished our first job!

THE VIDEOBIZ

Which goes back to the strengths and weaknesses discussion. My business partner was an extrovert—not afraid of the phone, not afraid to glad-hand. Granted, his family had standing in the community and I was from out of town with no roots at all. But credit where credit is due: we would have died without his finding a couple of early jobs for us.

My strength was in the cleanup position: assessing the need, writing a proposal, presenting the proposal and then leaving enough air in the room to hear the potential client say yea, nay or maybe.

Later, we'll talk about sales. But suffice it to say, if you're not capable of working the phones you need to find someone who is, even if on commission only. It's better than no outward activity at all.

CHAPTER TWO
Are You Ready?

The Service Business

Starting a new business, no matter how small, is a life-changing endeavor. It will change your life. Unless you are self-funding your own documentaries, you now are in a SERVICE BUSINESS.

Two words there: **Service** and **Business**. And you must take them seriously.

Let's look at what each entails.

Service. These activities are considered necessary services in your client-oriented business:

- Rapid response to everything, from initial inquiry to final delivery
- Complete written breakdown of projection expectations, deadlines, budgets

- Immediate notification of changes to budget and signed acceptance by client
- On-call 24 hours a day (rare but necessary)
- Meeting clients' schedule needs for shoots, personnel, etc.
- Written updates of client conversations, requests, changes, etc.
- Service with a smile

Business. These activities are considered necessary business activities in your client-oriented business:

- Accounting. You need to account for your income, expenses, and capital purchases. This eventually leads to a balance sheet, income statement and tax liabilities.
- Documentation. Save all project files and drafts. Get signatures from clients on approved budgets (see sample format later in book).
- Get a lawyer. At least have one selected in case you need him or her.
- Employee Handbook. Should you ever hire, your employee will want to know what your hours, holiday, sick day, insurance, overtime and other policies are.
- Proper business registration. Your state and the IRS will want you to register as a corporation, an S corporation, LLC or other entity.
- Sub-contractor agreements. You will hire outside services at some point. You should have a contract defining dollars and terms.

We will discuss some of these issues later in the book.

A Life-Changing Endeavor

Remember that chapter on handling stress? It makes more sense now, doesn't it?

I'm not saying you can't run a business on a cash-only basis, but even then you have to know if you're making money. I also assume that if you're reading this book, you're looking to get beyond a couple of hundred bucks here or there.

But very importantly, a successful business will have an impact on your family life, if you have a family life! A corporate-client-oriented business will involve travel—to shoot locations, meet staging locations, satellite offices, product installation locations, etc.

If you're more of a local, consumer-to-consumer type business such as a tribute video producer, local commercial producer, etc.,

there will be less travel, but the name of the game remains the same— service!

My staff and I have given up Christmases, birthdays, anniversaries, and even nearly given birth on the job!

If you grow large enough, you'll be able to delegate some of these "opportunities," but you can never delegate the ultimate responsibility you bear as the owner of the enterprise.

Why All the Caveats First?

I'm not trying to bring you down; I just want to share some of what I've learned about the less glamorous aspects of the video biz.

You have to commit to making it a business. Once you've done that, the fun can begin.

CHAPTER THREE
The Ground Floor

What Is a USP?

Your USP is your Unique Selling Proposition. This a phrase that was developed in the 1960s by a pair of advertising geniuses, Al Reis and Jack Trout, whose book *Positioning: The Battle for Your Mind* took the USP concept and modernized it for advertising.

Today, everybody and his sister is a video producer. That doesn't mean they're any good at it, even if they are making tens of thousands on YouTube. But the tools are ubiquitous and relatively cheap. It doesn't take $100K to get started.

So saying, "Hi, I do video!" will get you a big "So what!"

That's where positioning comes in. We've already started to position by choosing the kinds of videos we think we will be good at. But within that market, what sets us apart?

When we started in business, we were composed of a scriptwriter, soundtrack producer, slide shooter, artist and slide editor (putting the sides in the right order to match the soundtrack). The fact that these five jobs were done by three people didn't deter us from claiming that we offered **"Audio-Visual Production All Under One Roof."**

It happened to be the right message at the time. Most audio-visual companies were based around the photography, art or graphics capabilities of the company. Most used outside audio producers, and nearly all used outside script writers or simply produced scripts handed to them by ad agencies. We were untested, but we were unique!

It worked. We turnkey-produced our first jobs—two for small industrial companies (thanks to my partner's contacts), two for the arts (thanks to my contacts) and one major awards banquet for the local advertising association. Word of mouth developed.

In time, as we moved into video, we maintained the illusion that we did it all in-house. When video was first big it required heavy iron to get special effects, which meant we had to take our basic edits to post houses to finish. But we had a secondary USP—spectacular soundtracks that used library music to move along the edit, provide peaks and valleys and cause our clients to call our video "movies."

I don't know your USP. But I know if you examine your competition, examine your strengths and weaknesses and take a hard look at your proposed marketplace, you'll find it.

THE BASICS

CHAPTER FOUR
Choosing a Market (Where?)

Location and More

Location

Few of us have the ability to up and move at a moment's whim. But where we situate our business is a very important decision.

When I began, it was a matter of circumstance: I had spent four years in college at Marquette in Milwaukee, and my potential business partner was from Milwaukee. My wife-to-be had chosen to do her graduate studies in Milwaukee, so the decision was practically made. However, there were other unknown factors. Milwaukee at the time was an industrial giant, with heavy equipment manufacturers, four breweries, a full complement of arts and museums, paper companies and plenty of medium-size companies that others might have been ignoring. Government was paying for educational films as well. Our competition was graphically oriented, still treating slides as mostly speaker support. We had the smarts and gear to turn slides into something else.

So Milwaukee it was, and that decision served us well for nearly 20 years. But by the nineties, outside companies started gobbling up the cash-rich Wisconsin companies. No problem; Chicago was 60 miles away.

If you are planning on doing tribute videos for companies and families, you'll need to look at a different set of factors. How rich is the radius you want to market to? Are there institutions like high schools that may want reunion tapes? Once you develop a reel, you can easily specialize in these tributes and make more money selling them to corporations whose important executives are retiring. Awards Banquets that honor a person of the year are another possibility.

Let's say you want to produce local commercials. Cable TV allows specific spots to be played in just one neighborhood. This opens a lot of possibilities. But be prepared to be competitive, because retailers don't like to spend money. The best bet is to be efficient, keep your prices affordable and crank out as many spots as you can!

Financial Profile

Milwaukee was cash-rich. Many companies were privately held, family businesses that had done well. There were majors, of course: Briggs & Stratton, Johnson Controls, Harley-Davison, Schlitz, Miller, Pabst, Bucyrus-Erie, Nekoosa Papers, and we did work for them all. It was only the nineties when those companies that remained started internal video departments to save money. Later they disbanded these, depending on the current owner's financial philosophy. That trend of starting and disbanding and starting

again continues to this day. Satellite operations, however, continue to play a big part in corporate communications.

Talent Pool

Because we focused on the writing, we relied on Marquette's journalism school to provide us with excellent talent. As we moved more into animation and graphics, The Milwaukee Institute of Art and Design produced excellent designers and animators, as did the technical college MATC. Of course, occasionally we would "steal" a talent from a competitor, but this was rare; we preferred to train and grow our own. Examine your local schools and the quality of their graduates to ensure you have farm systems that help you.

CHAPTER FIVE
What Equipment Do I Need?

Why I Hate this Question

There's a lot of subjectivity here, that's why. Also, equipment doesn't create the magic; you do.

Plus, everybody has their favorite brand, their financial limitations, and their area of expertise, and no answer will fit all needs. There are basics, however, and my opinions, so let's combine the two and see what happens.

Computer

Y ou start with a computer. It does what it took $100,000 to do 20 years ago. Of course, there are variables. An iMac Pro in the $2500 range will run circles and even figure eights around what you might get at Office Depot for $300.

The variables:

Processor. Generally, Intel is a good choice, but Intel makes everything from the Pentium up to a quad-core i7. There is a lot of room for mistakes. For average video editing, look for a recent i5, preferably quad-core. More sophisticated use will benefit from an i7 and, again, quad-core if possible.

Video card or circuit. Most video editing software relies on the video circuitry to provide some of the heavy duty rendering or preparing of files for viewing. Most lower-end laptops use integrated circuitry that is part of the processor. This circuitry

continues to improve, but it isn't future-proof. And they rarely have enough (or any) stand alone memory to work without draining the main processor. Dedicated video cards are circuits from ATI and NVidia that offer beefier, more capable video and will be your friend as you advance to more complicated projects requiring 3-D animation or highly sophisticated effects.

Screen size (Not the size of the screen, but the resolution of the screen). Until you pass the $700 or so mark on a PC, or $1399 and higher on a Mac, you will be getting resolution in the 1366 x 768 range, which will not show you a lot of your editing program and will make you blind. Look for 1920 x 1080 or higher. Every **display** panel is made up of a series of dots called pixels, and the more pixels you have, the more detail you can fit on-screen. Most laptops come with low-resolution, 1366 x 768 screens that show far less content than high-resolution panels with at least 1920 x 1080 pixels. More sophisticated laptops and desktops allow you to hook up at least a second monitor to gain more real estate and may have even better specs. Today's MacBook Pro 13" features Apple's Retina display, which is awesome for video editing. It adds a lot more perceived real estate on the 13" and adding an external screen only doubles the fun! At $1399 (some discounts may be available) it is quite a bargain for the firepower it offers, and Windows 10 can also be put on the hard drive for dual system booting.

If you build your own PC and follow the above guidelines, you will be spending around $1200 plus for a bare-bones system (motherboard including sound, USBs, display outputs, etc.). You want to buy a computer with slots so you can grow the computer as your business grows, adding dedicated graphics, audio, Thunderbolt, etc. If you don't recognize all of these terms, make friends with a good computer dealer/builder. Laptop PCs can be had

that have killer specs. The Dell XPS 9570 comes with 4 GB of dedicated graphics, a solid-state drive, a Core™ i7-8750H processor, and 1920 x 1280 screen. The only thing you need to add is enough memory to make a difference (16 GB or 32 GB). Plan on spending around $1799–$2099, depending on add-ons.

If you prefer Mac (and I do, but I have worked extensively on both platforms), expect to pay more, unless you're in the used market (more on that later). We already discussed the entry level 13" MacBook Pro, but you can raise the stakes. A fully loaded MacBook Pro portable at 15" can cost upwards of $2399, but you will work successfully on that computer for at least three or four years. This includes a 6-core i7, Radeon Pro 555X with 4 GB of GDDR5 memory, 16 GB 2400 MHz DDR4 memory, Retina display with True Tone, and Touch Bar and Touch ID. The Retina display will give you even more real estate to play with on your 15" built-in or your add-on monitors. If you prefer a big-screen desktop, a 21" iMac with incredible specs starts at $1499.

Retina 4K Display
3.4 GHz Processor
1 TB Storage
3.4 GHz quad-core 7th-generation Intel Core i5 processor (upgrade to i7)
8 GB 2400 MHz memory, configurable up to 32 GB
1 TB Fusion Drive1
Radeon Pro 560 with 4 GB video memory
Two Thunderbolt 3 ports
Retina 4K 4096-by-2304 P3 display
$1,499 to $1899 depending on memory and SSD/hard drive.

What About USED computers?

THE VIDEOBIZ

Fact is, to get a start you can buy a used desktop or laptop, Mac or PC, for a fraction of its original cost. $500 can get you a hell of a Mac on eBay or Amazon, and you won't be disappointed. The main thing is that it meets or exceeds the specs for the software you are using. As an example, here is a recent ad on eBay:

<u>Apple 21.5" iMac - PREMIUM EDITION</u>
UPGRADED RAM & STORAGE - 16 GB & HUGE 1 TB Drive!
Quad-Core i5 Processor - "TurboBoost" to 3.3 GHz!
AMD Radeon 6750M Dedicated Graphics $699

That is PLENTY of Computer to get you started.
PC? Here's a recent eBay PC offering:

Lenovo IdeaCentre 720-18IKL Desktop PC, Intel Core i5-7400 3.0 GHz (up to 3.5 GHz max), 8 GB DDR RAM, 1 TB 7200rpm HDD, NVIDIA GeForce GT 730 2 GB Graphics $429 new.

It's an i5, but this is representative of a starter system that will get you going until your edits require more processing power.

The minimum specs you should consider in a desktop or laptop if you're on a budget is an i5 third generation or better processor, HD4000 shared graphics (better if you can find dedicated graphics from NVidia or Radeon).

Software

Now, the question of software: editing software, graphics software, scriptwriting software, budgeting software. There is free software out there—iMovie on the Mac, any number of free downloads on the PC (Windows Movie Maker was removed from Windows 10 by Microsoft).

But free programs are limited, sometimes by their capabilities, sometimes by lack of support communities. We want to brush up against the pros. For our purposes, therefore, we are sticking with two families of program—Final Cut Pro X on the Mac, and Adobe Premiere Pro and Premiere Elements on the PC.

Final Cut Pro is an amazing program and very intuitive for those just starting out. If you're a pro with years of experience it may seem a bit confusing, but it is incredibly capable.

THE VIDEOBIZ

Adobe Premiere Pro X is the granddaddy of editing programs, works on both the Mac and PC, and is also incredibly capable.

But let's be real about budgets: Final Cut Pro X is $299. That may be a bit much starting out. However, all upgrades are free—I've been upgrading since the program's release in 2011! Adobe Premiere Pro is $22 per month paid annually, or $31.49 per month paid monthly. That can be as much as $384 annually, and then you start over again the next year. Updates are included, since Adobe keeps track of your software via an app.

You'll need Photoshop, which is $10.99 per month, or Photoshop Elements. An excellent Mac alternative on the Mac App Store is Pixelmator, which you can own for $40 for life.

One way around all of this is to kill two birds with one stone by buying Adobe Premiere Elements combined with Adobe PhotoShop Elements. This combo gives you photographic manipulation and effects and a fairly powerful video editor, which skills can be translated into other editors later.

If you are writing scripts, most audio-visual formats call for a two-column system. This is easily set up in Microsoft Word as well as Mac Pages.

Your quotes should be created on a spreadsheet. Microsoft Excel, Mac Numbers or any of the free Office compatibles will do.

You may need to burn DVDs, and the best software for this is Toast on the Mac and Nero on the PC.

Camera

The emergence of 4K resolution throws open the question of cameras. Future-proofing your work would demand 4K if you're working in the corporate world, but home-market video is still acceptable as HD. Most projectors or monitors people use at a gathering will at best be HD, and the farther away from the screen, the less you can tell anyway.

But the camera serves another purpose—it defines how you look to the client when you show up for a shoot. And yet, quality cameras are getting smaller and smaller!

This is a case, once again, where new or used gear will do if properly selected.

What you absolutely must have is a camera with a mic input, headphone jack, hot shoe mount for attachments, reasonable zoom

and a modicum of manual control for special effects shots. HD is fine; 4K is better. A lens hood adds to the pro effect.

An example of a new camera that is affordable, versatile and high quality is the **Panasonic 4K Ultra HD Camcorder HC-VX981K, 20X Optical Zoom, 1/2.3-Inch BSI Sensor, HDR Capture, Wi-Fi Smartphone Twin Video Capture (Black, USA)**. It has a mic input, hot shoe adapter, lens hood and Wi-Fi so that you can monitor it on your phone.

Sony made a great range of HD cameras in the mid-2000s. One is the Sony HVR-Z1U HDV 3CCD 1080i HD NTSC/PAL Professional Camcorder. Note that it uses mini-DV tape as opposed to memory cards, but there is a quiet comfort in knowing you have an indestructible back-up of your shoot. It uses Firewire for camera control/inputting of footage into your hard drive for editing. It's a nice size, looks and is professional and has a lens hood, built-in mic, mic inputs, etc. Current price on eBay? $469.

Another option is a digital single lens reflex camera (DSLR). These have become popular for video because of their interchangeable lenses and adjustable depth of field. One I'm interested in is the fairly affordable **Panasonic Lumix DMC-G7 Mirrorless Micro Four Thirds Digital Camera with 14-42mm Lens (Black)**. This beauty shoots 4k and has an extremely effective anti-shake mechanism and interchangeable lenses. It also features an electronic viewfinder and a tilting touch screen.

What about action cams? Except as an alternate angle, an action cam provides extremely wide angle, somewhat distorted framing, although the 4K images can be nice. I'd use them for time lapse, alternate angles or drone flyovers if the occasion occurred. GoPro is

the go-to brand, but Amazon has a wide range of Chinese imports that do the job for a fraction of the cost.

You'll need a tripod with a fluid head for smooth panning and tilting shots. These can be had to start for perhaps $125 but will rise quickly in price. Again, the used market is a good place to grab a great tripod. An area that is growing is affordable motorized stabilizers for camcorders. Some have a camera built in. If you are shooting events, these can make for great walking shots without the usual vibration and bounce.

A good bargain for a fluid head tripod with quite a few extras and an eight-year warranty is **the Cayer BV30L 72 inch- Professional Heavy-Duty Aluminum Twin Tube Tripod, K3 Fluid Head, Mid-Level Spreader, Max Loading 13.2 LB.**

Audio Gear

Never underestimate the importance of a good microphone. There are on-camera microphones designed to "hear" everything that goes on in a room, and there are wireless or wired microphones, such as lavalieres, that are absolute necessities for interviews. These are pinned to the interviewee's clothing and focus only on that person's voice. A boom mic attached to a boom pole can be an asset when trying to record rehearsed or documentary scenes that feature more than one person. Keeping it out of the shot is the challenge. While most cameras have microphones built-in, an external mic suited to the job at hand is preferred. Don't forget a windscreen or "dead cat" muff to screen put the wind. Wind can destroy your interview and you won't hear it until you listen to the recording.

Recording "natural sound" is an important part of the game if you're doing documentaries or event videography. It provides a sense of reality that adds to the viability of the scene. Let's say

you're shooting costume makers in a professional theater. You could simply run music under the scene, but the sounds of conversation and sewing machines add a documentary reality that is undeniable.

There are two types of mics you should have when you're starting out (or you can always rent similar ones):

On Camera Directional Mic: Rode Video Mic Go Lightweight On-Camera Microphone w/ Stereo Extension Cable

Lavalier: Movo LV4-O2 XLR Phantom Power Lavalier Omnidirectional Microphone, with Lapel Clips and Windscreens (2 Pack)

They both have stereo mini-jack outputs, perfect for consumer or semi-pro cameras. Most camcorders have a line in or mic in, and these will work with them. As you build your reputation, business, and arsenal you might find yourself moving up to powered mics that require professional 3-pronged XLR connectors instead of the mini-jack.

Scanner

If you're doing a documentary, family history, high school reunion, retirement or other type of tribute video, you'll need a photo/slide scanner. While most printers have a scanning function, they can't scan slides, film negatives or other transparencies. Further, they are limited in surface to 8" x 10", which may not be enough for such items as yearbooks, photo albums, etc.

There are two types of scanner germane to our discussion: flatbed and slide/film.

Flatbed scanners need illumination coming from the scanner cover to illuminate slides and transparencies so the scanner can see them. Only more expensive scanners in the $200 range do this. Also, there may be a limit to how many slides can be scanned at one time.

Slide/film scanners are available on Amazon and there are quite a few of them, many mediocre. One that seems to do a good job at a reasonable price is the Kodak Scanza.

A flatbed scanner I recommend is the **Epson Perfection V600 Color Photo, Image, Film, Negative & Document Scanner**. It mixes excellent capabilities with decent pricing.

One other area to consider in scanning is the software used to make the scans. All of these items will come with software, but I recommend going a cut above with VUESCAN from Hamrick. It is compatible with all digital scanners and does an excellent job of batch processing, color correction and enhancement, and sharpening.

Make sure your scans are large enough so they can be manipulated in a "Ken Burns" style movement on the images. Scanning at 300 dpi will do the trick.

Projector?

If you plan on actually getting business, you will want to show your work in the best way possible. A five-inch tablet or cell phone won't do it.

Plan on creating your own movie theater with a projector and portable sound system. A portable monitor of some size would be acceptable as well.

Of course, some potential clients will have excellent presentation facilities of their own. Just make sure you bring the right cables to mate up with their gear.

One approach I might recommend is using one of the growing group of tiny DLP projectors. These projectors provide a short throw, decent image size and the ability to work in daylight (assuming you can turn the light off). Having a small portable high-refraction screen would be a nice touch as well. They take

HDMI inputs and an audio output so you can feed your small audio setup for decent sound.

The APEMAN Mini Portable Projector Video DLP Home Cinema Pocket Projector HD Support 1080P HDMI MHL Input Built-in Rechargeable Battery Dual Stereo LED Life up to 45000 Hours (Black) is one projector I'd recommend you look at.

CHAPTER SIX
How Do I Get Business?

Show Your Work (What Work?)

The first thing you will need is a demo of your work. This can be difficult if you haven't done any work, but as I said a few chapters back, this is where you scratch and fight for an opportunity to tell someone's story, **even if you must do it at cost or for free.** Video is a mature industry and there is plenty of competition. But the other guys don't have your USP, your style, your strengths and your stick-to-itiveness.

Find a target. Examples include the local chapter of the American Cancer Society and twenty-fifth or fiftieth high school or college reunions. Tell the story of a local arts organization. Tell the story behind a fund-raising drive or a benefit. *You've got to have a project in the can to sell more business.*

If you're having trouble finding a client, tell a story about your locale or community. What makes it special? What's its history? In the late seventies, when Milwaukee was experiencing some urban

THE VIDEOBIZ

flight and company merger-mania, we produced a 15-projector-plus 16 mm film extravaganza touting how hip Milwaukee actually was. We then offered a private showing and BBQ dinner on the rooftop of the building where we had our offices (which had a spectacular view of Milwaukee's slight but pretty skyline) as part of the local PBS station's annual auction. The winners were from Miller Brewing and we were suddenly exposed to Miller in an intimate way that would otherwise have been impossible. And yes, we got business out of it.

A former salesman of mine started up his own business, and he and his soon-to-be associates produced a "history of communications" video as the centerpiece of an invitational meet-and-greet with the local business community. They're still in business 20 years later, so apparently it went well!

In short, create your opportunity. All it costs is time and creativity.

Network (online)

Online marketing is a must, but it will only work supporting your own flesh and blood efforts. You need a decent web site that features examples of your work, endorsements, a bit about you and a regularly updated blog. Pictures of you and your team at work are a plus, so always be capturing work circumstances with your phone.

I recommend getting a good URL (web name) and using it for your website and your email address. Coolvideos@gmail.com won't make it. Yourname@coolvideos.com is the way to go.

Having spent 20 years marketing online, I can tell you that the pull and power of websites is greatly diminished. You have to have one, and you have to keep it up. But I would recommend a site builder like Strikingly.com or any of the other "build it on our platform" sites. You can get lost in WordPress making a site, and you need to be making videos, not websites!

Facebook is not really a place for pros. LinkedIn is, but it has mostly become self-promotion and your followers are job-seekers or your competitors.

There's still life in Instagram and Twitter, especially with Instagram's renewed emphasis on video.

And YouTube and Vimeo are excellent places to host your videos for use on your website and sharing with potential clients. Both, however, search for copyright infringement, especially when it comes to music.

What you should be using all of these tools for is building a mailing list. Potential clients like smart information, and a newsletter featuring your latest projects and production tips makes you an authority.

Club Your Way Up

One thing hasn't changed in all the years I've been producing: person-to-person communications, whether in an organization setting, social event, service club or lead generation club is still the best way to gain trust and business.

There are many opportunities to meet people: **local advertising and marketing clubs, local service organizations, arts support groups, fund raisers, etc.**

There are lead-trading organizations like BNI, which says, "We help our members grow their business through a structured, positive and professional referral program that enables them to develop meaningful, long-term relationships."

Meetup offers thousands of group meetings on a wide variety of subjects via the web. Join a meeting that reflects your interests,

especially those interests tangential to either your business or your customers' businesses.

The American Advertising Federation is a national advertising organization that has local clubs throughout the country, many of who run local ADDY awards shows. I had much success in this group.

Advertise

Targeted advertising and public relations can have an impact but can also be a slippery slope. The trick is to target: by buyer, by field, by geography. Facebook and Instagram have the tools for this and at some point, it's worth a try, especially on Instagram, which still has credibility and loves video.

You can add video to your Instagram account either by creating a 60-second live Stories video (which doesn't really have to be live—there are ways to upload it as live), or you can upload any length video to your feed. Stories videos have to be vertical, as if you were simply shooting a live video with your phone in portrait mode/orientation (the tall version). Feed videos can be any dimension—16 x 9 is most popular. This could be a sample of your work or a personal introduction to who you are and what you do.

You can then boost your video views by "boosting" the video post for a predetermined price on Instagram. TRIM YOUR AUDIENCE to

your geographical location, type of potential buyer, and interests of the potential viewer, whether end consumer or business buyer. If you have niched your business by subject matter (say, only the pharmaceutical industry or local commercials) you will want to create an audience subset for this as well. You can save your profiles and reuse them, or adapt what Instagram says is working for you by creating a look-alike-audience.

Publicity

Publicity is exposure in the mass media, including television, radio, Business Journals, newspapers (online or print), influential blogs, and club newsletters. These are considered outside "impartial" sources and being featured in them adds a great deal of credibility to your company's image.

All of these venues are looking for content, especially feel good success stories within their area of influence. Where I live in New Jersey, that would be The Asbury Park Press newspaper, New Jersey News 12, 101.5 FM, and any number of web sites dedicated to New Jersey news and information.

The key word here is **news**: You have to be offering a story to "the press" that is newsworthy.

Some examples are:

- New equipment.
- A recent interesting video or meeting you produced.
- A human-interest story about you or a coworker.
- A new marketing gimmick you're using that's unique and having results.
- Charitable work.
- Surviving a challenge or disaster (an example is below).
- Announcements in the business section, such as opening of your business, new hires, recent clients, or something you produced for a charity or arts group for little or no money.

When my first business could finally afford an office, we took space on the second floor of an old 19th century building called The Metropolitan Block. We chose the space because our film processor was looking to sublet their space, and it had two film-changing darkrooms that could easily be turned into an audio station and an announcer's booth. We were in that space for three years.

An advantage we had that we were totally unaware of was that we were located right across the street from the *Milwaukee Journal*, Wisconsin's largest newspaper. It helped that we were across the street. It was easy and quick for the paper's photographers and reporters to get to. One of my partners came from a family of reporters, and the family name was well known. More than once, he called the Business Page editor or reporter to suggest to them that we had news. One time, it was our investment in film equipment. Another time it was building out a spectacular theater to show our work in. Not later, we were featured when our building was destroyed by fire. It was the biggest fire in Milwaukee up to that time.

That's why we were only in the space for three years! But the resulting publicity was enormous. "You are the guys that were in the fire! Sure, we'll meet with you!"

The publicity continued as we relocated, and we added fuel to the fire (LOL) by buying ad space on the newspaper's business page thanking all the people that had helped us during our downtime, even "Mel, Our Mailman".

Our tenth anniversary got us publicity. Our PBS documentary on Eugene O'Neill got us publicity (and a positive review). Our work as the official media producers and photographers for the Milwaukee Repertory Theater got us plenty of ink in their monthly newsletter, which was read by Milwaukee's corporate elite and their spouses.

Our new company and our move into video and interactive laserdiscs garnered stories. And now, being known by any number of reporters, we were often called to give media-related quotes.

We also wrote articles for our industry's major magazines; I was a regular columnist writing about this newfangled thing called "personal computers" in *Audio-Visual Directions* magazine, and when we did a large stage show featuring a 50-foot vacuum cleaner and a Star Trek parody, we earned articles on that.

And we produced slide shows and videos for The Milwaukee Journal for 15 years.

CHAPTER SEVEN
Competing for Your First Job

Solving Problems

Unless your first client is a friend or a friend of a friend, you'll be competing with other firms for the business. Most businesses and even home consumers will want to compare budgets and capabilities of the potential suppliers. How do you distinguish yourself?

Identify problems and solve them, even before you get the job. This way YOU set the rules, and other guys can't compete.

Your secret weapon is your proposal.

The Research

A proposal starts with research. In your first meeting with the potential customer, you have the one single opportunity to gather enough information to set forth a video solution that answers the customer's needs.

A typical supplier will pitch themselves—their experience, their equipment and their pricing profile. They are selling nuts and bolts, not solutions.

The first meeting is intended to lead to you submitting a proposal. Most people—your competition, perhaps even the customer—think of the proposal as simply your price.

But you know better. You want your proposal to prove that you listened and asked the right follow-up questions.

What do you need to know?

1. Purpose of the video. Why do they need a video? New product introduction? Meeting? Opening motivator? Tribute?

2. What information is important to convey?

3. What makes this product, person or company different?

4. What feeling (emotion, vision) do you want the audience to experience?

5. What action should they take?

6. What is the history or background of the topic of the video—how did we get "here"?

7. Ask for a summary description from the decision maker as to what the video should be. Their words will often give you clues as to what direction to take.

8. Your competition will ask, "Do you have a budget in mind?" That's because all they care about is what they can charge, not what problem they can solve. But when you prove you can solve the problem, you are no longer talking "five- or ten-minute video," but instead talking a budget that reaches a specific end—a solution. A solution may mean the buyer will gain extra prestige in the company, perhaps a raise, perhaps a corner office and a new title. **This is the kind of impact you can have on your clients' lives and their companies' futures.**

The Proposal

The proposal is where you distinguish yourself and unleash your secret weapon: **content!**

The good proposal involves writing—lots of it. You are proving that only you offer a solution to their problems and a road map to their personal success, *and you have the facts to prove it!*

The basic elements of the persuasive proposal are these:

Introduction

Background

Goals

Intended Results

Creative Plan

Outline

Actual Results of This Proposal

Summary and Ask for the Sale

The tone should be formal but humble, and very enthusiastic. Ideally you will not just be submitting this proposal, you will be presenting it in a follow-up meeting. **Live presentation** is one key to this method's success.

Let's take a look at each element's goal and content.

Introduction

This is simply reporting what the document is about. "(Our Company) met with (Your Company) to discuss the possibility of producing a video project concerning your new product, (name of product). What follows is a summary of our research, our goals, our creative approach and the results of that approach. This is a living document and will be updated as new requests or information come forth."

Background

Here, you show you were listening. Describe the nature of the project, specifics of the project, intended deadline and a very broad statement of the intended result.

Goals

Here you set forth, most often in bullet or numbered fashion, the goals of the project: informational, motivational, actions anticipated upon successful creation and presentation of final product.

Intended Results

This is an extended discussion of what the audience will learn, what actions they will adopt and what their change in attitude will be after a showing of this finished video project.

Creative Plan

This is the guts of the proposal. It should be presented live, in an ad-lib fashion, but covering all the key points of your creative plan, approach, details, creative twists, whether it is straightforward or humorous and connections that will be made with the audience.

Outline

This can also be called *"Key Points that Will Be Covered,"* because it is a laundry list of the information that will be presented, along with key scene ideas to carry the information and motivate the audience.

Actual Results of This Proposal

Here you deliver the payoff: a detailed discussion of what will be accomplished by the video. There should be a few more results than

what the customer asked for. This can be delivered in paragraph or list form.

Summary and Ask for the Sale

Here you tell the customer how much you want to work for them, how interested you are in the subject matter, and how excited you are to have an opportunity to produce this specific project because it's so damn interesting to you and you think you can really inspire your team with this challenge.

In a new page, you offer a **Production Timeline.** It is good to present a timeline that delivers before their deadline, but not too early.

Finally, **on a new page**, you present the **Production Budget Spreadsheet** (in other words, your quote). This should actually be done on a spreadsheet, because the math will be correct, and you can make changes easily. See the next chapter for a discussion of this element.

The Price

How you price your projects depends on several factors:

The competition. What do other people or companies with similar end markets charge? For the end consumer market where you might be producing a tribute or memorial video, you can probably glean some insight from the internet. For the business market, it may be a bit tougher to come by competitive information, so you may have to use subterfuge. Have a business friend query a local producer as to their range of prices for a "10-minute new product introduction video," or something similar your friend can talk knowledgeably about.

How much do you think you're worth? This is important, because the equation for quoting a project is hours projected times the hourly rate. The home market will be less than the corporate market, but depending on the type of activity (writing, shooting, etc.) you might be charging anywhere from $25 to $100 per hour.

Are you winning or losing projects? The first reason, regrettably, is always price. If the potential client is willing to discuss what you could have done differently to get the job, try to find out what the winner quoted as the bottom line price.

Which market do you operate in? Milwaukee prices, I found out, are lower than New York prices. This is due to two reasons. The first is the cost of living and operating in a market. Office rental, gasoline prices, subcontractor rates, meal cost and more add up and will be more in a bigger market than a smaller one. On a more personal level housing, schools, transportation and groceries effect what you need to live on. The second reason is the expectation level of the potential clients. A larger market is less forgiving of failure and will pay more to someone they feel will guarantee success. In addition, they're used to paying higher prices, and not charging what the market can bear may make you look like a novice.

Did you justify your price? See our discussion of proposals.

Shut Up!

My father was a salesman for what was at the time (1950s) the leading men's hat manufacturer in the country. Just in case he's looking on from above, I will add that he graduated to Vice President of his division, Cavanagh Hats.

I learned two important sales lessons from him.

In college I told him I didn't want to be a salesman, because I had plans to write and create for a living. "Everybody sells," he said. This book proves he was right.

When I was 17, I launched into a major session begging him to borrow the car for the prom. During my pitch ("I'll take real good care of it," "I'm a really good driver," etc.) a small smile broke out on his face. I kept blathering on. Finally, he could no longer take it. "**Shut up!** You made the sale!" he yelled, laughing. He later told me, "Always know when it's time to shut up. Never oversell. In fact,

sometimes find an excuse to leave the room because they may want to make a decision but they can't talk in front of you. Give them a chance to say yes!" He was right.

Years later a salesperson working for me and I were pitching a large corporation on producing their annual meeting, an extravaganza with an ever-growing budget. Each year had to better than the last. I made a pitch (this was an introductory meeting), showed samples (our samples were incredible by this time) and decided to wrap when I saw they had my father's look on their faces. They complimented us and I knew they were sold. All we had to do was leave.

That's when my salesperson decided it was time to talk. Ten minutes of corporate-speak and misplaced generic production talk later, I knew we had gone from the front runner to dead last. I could see it in my prospects' faces. And when my salesperson was done, the room emptied completely except for the direct client, who rushed us out of the building without a word.

KNOW WHEN TO **SHUT UP.**

Handling Objections

No proposal presentation ever goes 100 percent perfectly. There will be questions, for which you must have answers, and there will be objections—to approach, to price, to time estimates, almost anything.

If you have answers, good. Use them. If you don't, be honest. If it's a pricing discussion, you may or may not be able to answer on the spot. If it requires rethinking the approach to get a price down, tell the client that and offer to prepare a new quote reflecting various cost savings or concessions.

Clients have budgets, and it is important to be respectful of that. I rarely opened a project discussion with, "What's your budget?" because that sets (usually) an unreasonable ceiling on the project. The client will set a low expectation with price, but in his or her mind they will still be envisioning success. But at some point, if there has been a pricing discussion, you will have to ask them what

their ceiling is. Then you will know whether to pursue the project further or not. Remember: **Your job is to make money.**

Making the Deal

If you get the go-ahead, have the client sign the proposal quote page. You should have brought it in with your signature already on it. Review the details of payment, mention any price variance that you require (usually put in so that you have room to pay a little extra for something that will improve the project) and summarize that whole discussion in an email.

You're on your way!

CHAPTER EIGHT
The Zen of Creativity

The Basics

C**reativity.** It's a major component of video production. Your creativity will spring from your upbringing, environment, genetic predisposition, and your use of your particular craft.

Creativity in our kind of video may be judged differently than TV or movie creativity, depending on the role you play in your production and the expectations of your prime audience—the end viewer.

The client is the representative of that audience, and will make judgments on your efforts along the way on behalf of what he or she thinks will motivate the audience toward the desired action or change in attitude.

But being creative in "sponsored" video, i.e., paid video production, has various structure rules to help us along. You saw an example of that when we discussed proposals and proposed project outlines.

The first and simplest rule is the one that is the foundation of any story— **beginning, middle, end.**

And to that end, the second rule is to **get from beginning to end with the least amount of perceived wasted time.** Audiences are obligated to sit through your presentation. They can't simply leave in the middle because they don't like your approach or disagree with the goals of the video. They're paid to sit there. Or, in family videos, they're obligated out of respect to the honoree or because they got free food.

Working with my own writing and that of many extraordinary writers in my business, as well as judging productions at various national and international competitions, I realized the second rule:

No repeated concepts or information, except for the wrap-up (the end) of the video, when all that has gone before may need to be summarized, or where circling back to the opening premise is necessary to prove you paid off that premise.

Repetition in linear video production will lose an audience quickly. It treats the audience like children, and like children, they're bored easily.

Length of the video is always a point of contention. Length tends to be a method for lazy producers to quote video prices, but "$1000 a minute" is short hand that I have always refused to use, unless the client absolutely didn't understand the complexity of producing a video and which areas tend to cost more.

It is harder to produce a shorter video than a longer one, and it is possible to take the same amount of information and deliver it as a

five-minute video or a fifteen-minute video. But only one length can be right. Always use the word "approximately" when discussing length, and always explain to your client that videos are like water—they find their own level.

Next, we'll discuss basic structures of three different kinds of videos, to get you started toward being perceived as "creative." See? I circled around.

Corporate Overviews

The corporate overview is a basic company introductory video. It can act as a sales video, a training video, a public relations video, an annual meeting opener, a press conference opener. It can be shown to small and large in-house audiences, used in trade shows, sent to potential customers on DVDs or flash drives, or hosted on the company home web page.

These are not commercials. If someone asks you to make a video "like those Geico commercials" for a corporate introduction, proceed carefully. There is a lot they have to learn.

This is not to rule out humor entirely, but humor is very subjective and hard to write (and even harder to get approved).

Conversely, a clever conceptual introduction to the video can have great benefits.

THE VIDEOBIZ

The basic corporate video structure that follows is based on years of writing and producing this very type of video. It should be taken with the advice that "rules are meant to be broken," i.e., modify it to your client's needs.

Opening premise. This is where you state your goal, whether it be in conceptual terms or more straightforward. For instance, in doing a corporate overview for a northern Wisconsin paper maker, we were impressed by the care they showed to their most important resource: trees. We started with a swooping helicopter shot (today it would be a drone shot) over one of the many forests they owned in Washington State. The through-line of the script was to occasionally come back to the trees—their growth, their cutting, their processing and their renewal through the careful planting of new trees to replace the old ones (reforestation).

A **history** (brief summary) section is next. Potential customers want to know what a company stands for besides making money. What are the company's founding principles, and do they still have meaning today? This won't always work, especially in the age of conglomeration, or in the case of very young companies, especially tech startups. But if a company has a rich history, take advantage of it. If it has brand names and products that are recognizable, it's worth showing a few sections of that. Sometimes even nostalgia with the use of lifestyle photos or video will help enrich the perception of a brand or company's name.

Products. This is a summary of the company's products, whether hard goods or intellectual services.

People. This where you show the company's hard-working executives, craftspeople, factory workers, researchers—whoever

makes or creates whatever it is they do. People want to believe in people. Make sure you get a picture of your client in there!

The future. Where is the company going? Are there new products coming? Does the company plan to be at the forefront of its industry? Of course, they do. They're not going to say they're happy treading water.

The payoff. This is where you circle back to your opening premise and pay it off with stirring music and a video/photo montage of everything the audience has seen. You need to let them know the video is over, and to encourage applause or at least positive head nods.

The trick to a good script is to keep moving forward and not to repeat something in a section where it doesn't belong. Audiences hate going backward; it violates basic story structure. Unlike a freewheeling discussion, repeating information treats them like they're stupid. But they watch TV and movies all the time. They know what works and what doesn't.

You should also use music as a mood map—it should change to reflect each section or change in direction. If the history section talks about the Depression, you need to shift from happy music to more foreboding music. Never repeat music, except as a reprise of an opening piece that set the theme and tone of the video. You can bring back this one piece, if it is strong, or if you are having original music done, as the payoff of the video.

Tributes

Tributes—the videos dedicated to a special person's life and achievements—follow different rules than a corporate message.

Tributes will follow a chronological structure. It is the nature of life. It will be made up of raw materials provided by the client, although you may add cultural and historical references to aid the chronology.

Therefore, you are at the mercy of the client to provide everything they have in terms of pictures, video, films, yearbooks, newspaper articles and memorabilia (medals, trophies, etc.). You or someone you pay will have to transfer these materials to video for editing.

The client will want to use their subject's favorite music in the video. This will have major impact on the subject if he or she is living and will have nostalgia value for the audience. But I must warn you that there has been for years an ongoing debate about the

legality of this. If this is a major presentation in a large public venue, I would urge you to check with a lawyer, or if it is a corporate client, have your client take the responsibility of checking with the company's lawyers. This is to protect you. Once again, this is not legal advice, and I am not telling you specifically what music you should use.

The no-repeat rule applies here too. Except for an ending where you may do a fast montage of history to emotional music, don't repeat pictures. Tributes are typically longer than the average corporate video, and repeating pictures will just frustrate the audience because they will feel the video is not making progress.

Also, be careful that you are not ending up with two endings. It is possible to create two peaks in a row near the end of the project, simply because of the nature of the material and type of music you end. A high point followed by another high point at the end of the video may lead to premature applause and a "real" ending that falls flat.

Meeting Considerations

We call them "major meetings," but any meeting with a sizable group where the audience members are passive participants counts.

I am not going to discuss creative for big meetings; this is a subject for another book.

But I will tell you that there are many goals for videos in major meetings, especially the meeting opener. The company may want to convey a major new direction or plan, may want a video to support the theme they dreamed up, or may simply want something exciting that can be tangentially tied to the company to set a positive tone for the meeting.

Meetings can last hours or days. They involve meeting themes (Dare to Be Great!), and animating the theme and company logo is a must. Depending on the budget, you could be doing an opener that

is all animation, all 3-D or even virtual reality. We once created an entire humorous stage play that acted as the glue sewing together videos throughout the course of a day. This was at the Chicago Auditorium, a grand old theatrical venue.

But here are some things that are considered standard operating procedure for the wise meeting producer.

Chill the room. The room will be filled with hundreds or thousands of people, and people generate body heat. They will be sitting close together. In order for them to be comfortable and respond to what's on the screen, they can't be falling asleep. Chilling the room to an almost uncomfortable temperature will allow body heat and equipment heat to raise the temperature naturally. The client's boss will tell you in at the early morning rehearsal, "It's cold in here!" and your client will tell you to warm it up. If the audience is coming in right after rehearsal, don't warm it up. Lie if you have to.

Use walk-in/walk-out music. Some people use pop tunes or jock jams, or they may select music from music libraries intended to motivate. At a really big meeting, you may have a customer theme created that will have variations to use both in your opening video and in subsequent walk-ins and walk-outs. Developing a custom music theme for the meeting builds a sense of group identity.

Be there and "feel the room." Are they awake, asleep? Is the sound too loud or too low? Make adjustments. And always, always clap from the back of the room at the end of your video to start the applause. Others will follow, and your client wants to hear applause!

Pacing

We've already discussed the no-repeat rule in the corporate video section. But pacing is a universal concept, no matter what the video. Therefore, there are some rules and concepts about pacing that all videos share.

A good video is like a great fireworks display. It starts with a bang and ends with a boom!

In between there are ups and downs. You use music and pacing (fast, slow, happy, serious) to reflect what the client wants the audience to "get" in a certain part of the video.

Depending on the video, it might need **"catch-up points."** People, research has shown, can only handle at most seven concepts at one time. At some point you need to slow down and let the audience absorb the information, dump it from the conscious mind into the unconscious mind, and begin again. The catch-up points aren't

long—they may be represented by allowing the narrator a sentence or two without having music playing under the narration, or they could be a bit of humor, or a small video montage with just music. All work equally well.

In the case of tribute videos, the chronology provides catch-up points. Once again, keep the pace varied and continue to make progress by only showing pictures once, at least until the ending. People may say, "I didn't have enough time to see all the pictures." Provide the client with a disc of the pictures you used, and you will have neutered that objection. This is a show, not a book.

Music, Video, Animation Libraries

Beautiful backgrounds. Tear-jerking photos. Motivating music. Extraordinary animations. In your quest to tell a story, you often dream of things you can't generate in-house. But just because you need a shot of a *toddler making a fuss at dinner time*, doesn't mean you have to take half a day to shoot it, or even to shoot it at all.

In your search for resources, you are going to run up against budgetary issues. Your friend in these cases are the various resource libraries that offer music, video, pictures and even animation and editing templates for your use "Royalty Free".

That doesn't mean these assets are free. There will be a single use charge for the element, but you do not have to renew the license for continued use on an annual basis.

There are two buying approaches provided by these libraries. Some offer assets for a single charge per clip. Others let you subscribe for a year on an all you can eat basis. Oh, and some are free.

Free libraries are usually offering public domain footage, usually of a historical nature. The Internet Archive and it's Prelinger Collection feature a wealth of newsreels, industrial and marketing films, and old TV shows that are out of copyright which means you can download assets for free. There are some music libraries within the archive as well. However, these will not for the most part be contemporary. Pond 5, which is a charge per asset library, hosts a wealth of war footage shot by the Armed Services and therefore is in public domain. Motion Elements is a new pay per use library that also offers free elements on its "Free Page".

We have included a list of footage, picture, illustration and music libraries in the Appendix at the end of this book.

Or, Google with the words "Video Library", "Music Library", "Photo Library", "Illustration Library", or "Template Library" to find almost any asset you need!

CHAPTER NINE
Producing Your First Project

Who's in Charge? You Are!

Know your role.

And your role is "god."

God, the protector of all that is creative, all that is messaging, all that is the final result.

It's your reputation, and there is no stronger advertising than word of mouth.

And bad word of mouth travels 10 times stronger than good word of mouth, so you don't want bad word of mouth.

Since it's your reputation, you must control all aspects of production. This is your first real job. Whether simple, complex, freebie or paid, it's the most important job you will ever do.

THE VIDEOBIZ

No matter what your primary role (editor, shooter, script, director) you must have a VISION of the final product in your head. You can make adjustments and changes as you go along, as long as they continue to reflect your VISION of the final product.

Luckily, you already have a creative plan everyone has agreed on: **the accepted and signed proposal.**

Now it's time to flesh that proposal out and double check the timeline vs. the budget.

You have made assumptions about the budget. If you are using subcontractors, hopefully you got a quote from them based on your schedule assumptions. Now it's time to contract them for the agreed-on price and proposed deadline for their part of the production.

Managing the Budget

The budgets I have shown you (see Supplemental Materials) are based on a fixed-quote projection. This is the smoothest way to sell, but it involves being slavish to your quoted production time estimates. If I CHOOSE to go over the time predicted, that is my choice and I don't charge anything extra. This the price I pay for the client having accepted a realistic budget as opposed to a low-ball budget, and for my assumed autonomy as production god. Smart clients know that over-involvement in the process (outside of necessary involvements like providing shooting locations, background scene on-camera extras, photo or video archives) leads to confusion and second guessing.

When the client requests a change that DOES impact the budget, you need to communicate that budget change request immediately. Otherwise, it will be lost in the fog of war.

The smaller the budget, the more minutiae you will likely have to report as added expenses. For instance, if I am doing a shoot for $200 per day or less, I may need to charge for mileage and meals, especially if I have other crew there. If I'm charging experienced-professional rates (as you will, someday), say in the $800 to $1200 range, I'm not going to bother with that minutiae. All it does is remind the client of how much he or she is paying.

One of the basics of this "quoted" approach as opposed to an open-ended price per hour is that you can request up front and progress payments. These are typically one-third up front, one-third following approved script (some people prefer after principal videography), and one-third on accepted completion of the project.

If you're dealing with individuals or families, this would tend to be on a cash (no terms or payment plans) basis. If you're dealing with the corporate world and large budgets, you will probably have to accept terms such as net 30 days. The exception we often made was to try to get the first third up front before beginning the project. On the proposal, this is the "Required to Begin: $XXXX" near the end of the proposal.

Managing the Creative

You don't have to be creative to run a creative company. Many of my competitors were businessmen who enjoyed managing creatives but were primarily operations experts. Still, they had to manage creatives. Still, the creative process begins with the proposal, which is written, and then the script, which is written.

We said earlier that the proposal was a "living document" and the actual production is also living.

This is because during production you will discover things you didn't know that might impact the success of the video.

The **script or outline** comes first and whether you wrote it yourself or hired someone, you are the keeper of the script.

A-V scripts come in two columns, audio and video. Audio is for the words and hints about sound effects and music; video is where you

THE VIDEOBIZ

call out the shots necessary to tell the story. This eventually leads to a more complete and detailed standalone shot-list.

Tick Borne Diseases Spot 1 AV Script 4/26/16	Tribute Video
AUDIO	**VIDEO**
MUSIC UP AND UNDER, OMINOUS	Various Pike County Nature Scenes
NARRATOR: What you don't know about Lyme disease can kill you.	TEXT: What you don't know about Lyme disease can kill you.
NARRATOR: Because	Close ups of various ticks, some engorged, perhaps biting.
NARRATOR: One bite may transmit many disease-producing organisms causing a life of suffering, neurological damage, heart disease... even death.	Stock of suffering children, adults, elderly-- **Anaplasmosis, Ehrlichiosis, Lyme Disease, Bartonellosis, Babesiosis** float over scenes.
NARRATOR: One tick parasite can be acquired by blood transfusion.	BLOOD transfusion scene, with **Babesia** floating above
NARRATOR: If you suspect a tick borne disease, ask your doctor for a panel of tests.	People showing symptoms TEXT FLOAT: fever, chills, rash, headache, pain, fatigue, dissolves to: Medical care scenes
NARRATOR: Learn how to prevent tick borne diseases. **Research tick borne diseases online.**	TEXT: Prevent TBD. Typing into search bar TEXT: Research tick borne diseases online. Subhead: Donations provided by TBD SUPPORT NETWORK,INC
MUSIC OUT	TEXT: The content of this message is not intended to be a substitute for professional medical advice, diagnosis, or treatment. Always seek the advice of your physician or other qualified health provider with any questions you may have regarding a medical condition. BLACK

A change to the audio will often lead to a change in the video, and vice versa. Sometimes you will find your script repeats itself

somewhere along the line, and you decide to trim that repeated information for better story flow. This kind of change is not something I would discuss with the client unless it is a hot button issue. When the project is reviewed, it will be judged on how it plays on the screen, not on the page.

Each of the two **script** columns have their own job to do, and that is rarely the same job. Remember, the audio is there to move and excite the audience, and to keep advancing the story. Repetition within a single concept can tell the audience that they're in for a dull ride. By this I mean that if your script says "You want to make money" and it is illustrated by a stack of dollar bills and the sound of a cash register, you're not exactly being clever.

The next area that really impacts creative is **the edit.** I don't mean all the effects, text, animations and other pretty stuff. I mean the **relationship between words, music and picture.** If you can't tell the story visually (unless this is a YouTube-style "explainer" video), there is something wrong.

Pacing is everything, and that starts with the music. Any editor worth their salt will "edit to the music," meaning they will develop an editing rhythm based on the percussive sounds, musical swells and general emotional feeling inherent in the music selected.

Let's talk about music.

We all know there are various styles of music, and if you were simply to use what is on the Billboard 100, you might think today's music is filled with repeating phat beatz, overproduced pop or gooney love songs.

But that is not music as a universal term. Your clients believe their videos are important, make-or-break vehicles. That calls for universally accepted emotional/motivational "movie music." It can have a rock motif, dance percussion, even wailing guitars, but it still must represent an emotion and tell a story.

The craze to lay down beats continues a trend of the last ten years or so—loopy music (music constructed from short music loops) that is devoid of beginning, middle or end.

Music tells an audience how to think. There should be different pieces used for different parts of the script (assuming a length of more than three minutes or so). Imagine *Star Wars* without the music. Case closed.

There are exceptions and they are plentiful: original music produced to fit the script, original or parody songs designed to act as "anthems" for a large audience, and take-offs on pop culture that require music that "sounds like" the movie or TV show being replicated.

In the Supplemental Materials, I will offer samples of videos with soundtracks I think do a good job of what we have just discussed.

As you produce more projects over the years, you will develop an innate sixth sense about what works and what doesn't. Moving a quick cut 15 frames this way or that way can have a major impact on an audience (and neither you nor the audience know exactly why!).

Once all the pieces are roughed into the edit (videography, music, graphics, animations, titles, interviews, etc.), it is time to make

final adjustments. Everyone has worked hard, but that doesn't mean the work is over. Over the years I have had first edits be exactly what I was looking for, and other edits that just missed the mark. But when the process and adjustments were over, they all were the best job we could put forward, and knowing that, we could be proud of our work.

Five Steps Toward a Creative Video

My first business partner often described the multimedia and video work we were delivering to our clients as "holistic." I think he might have thought of that word as "whole-istic," which means we do everything, but both definitions apply. When creating a successful video project, there are many things that go into it beyond shooting and editing. You have to look at the big picture.

1. Envision the final result. To properly know what to deliver, you have to assess the company's needed result. Is it motivated employees? Educated employees? A well-developed position on the #metoo movement presented to the press and community groups? You are there because there's a problem, or at least a need. Find it. Know it.

2. Know the audience. Age, economic makeup, position in the company or community, their belief (or lack thereof) in the cause or

company, **their own needs and desires, their motivations** (company, family, pop culture, etc.).

3. Deliver logic. We call it "Premise/Proof." **You set up a premise, then you prove it.** This way you make the rules and set the expectations. The *American Toenail Institute* is changing the world of ingrown toenail sufferers? Okay, prove it. Give me facts.

4. Deliver emotion. More than proof, you need emotional buy-in. Little Jimmy has suffered with ingrown toenail since his birth. ATI's research has developed cures that have changed little Jimmy's life. Before and after pictures, tearful interviews with Jimmy's mom and a thank you from the parents to ATI will tug at the heartstrings. Give me tears.

5. Don't underestimate music and sound. This is more technique than a key, but it does separate powerful producers from their everyday competitors. What made *Star Wars* more than just a sophisticated version of *Flash Gordon*? The music. What makes CNN the most trusted name in news? James Earl Jones, who does their network ID voiceovers. Try watching any chapter of *The Fast and the Furious* with the sound off. Boring. Music, sound effects, natural sound, quality voiceover interpretations and total project pacing are all the province of the soundtrack. Before video, there were slideshows. The audio—the soundtrack—always came first. (We wrote the scripts too, which helped.) It set up all the rules: pace, emotion, transitions, and **the moment of final buy-in—the finale**. This carried over to video as well. Lousy and **repetitive audio will drive your audience to distraction,** and you will have gained nothing. You couldn't deliver on your promise of the final result.

Managing Clients and Expectations

Some clients are poised under pressure; some are so nervous you'd think they're about to have a breakdown. Just like real people! So how you communicate with them and manage their expectations is very important.

Here is the one thing you should remember: clients don't like surprises.

Most of your clients report to someone, and their choice of you as their video supplier will be under constant scrutiny, since they in their position are under constant scrutiny. You can help make or break their careers.

The way to keep things cool and calm is to communicate. Not every detail—just the important ones.

"The shoot went well."

"Weather got in the way and we have to shoot again tomorrow."

"I need one more day for the script."

"We're on budget."

"We'd like to add a drone video over the new facility—can we up the budget a little?"

What clients don't want to do is go back to their boss and ask permission. But they will if they trust you and are comfortable in their job.

I had one client who, once we were awarded the job after presenting to him and his boss, never shared a detail with management until the project was finished. He trusted us and our creative instincts and assumed that the expectation we had created on paper would be exceeded by the actual end result. This was very rare, but it actually worked for the length of our 20-year relationship.

But there will be clients that nitpick, and you must live with that. Share what you can so they keep feeling comfortable. Don't panic them with the little stuff; this invites them to review every little step you take. Only if you're in real trouble or really have good news should you report.

In olden times we used to create "production reports" on paper. This was done on a weekly basis. You could do the same thing via email, which creates an electronic paper trail.

Remember, no surprises.

Being Relentless

To be a real success, you must relentlessly pursue your goals and the goals of your clients.

Be relentless—meet all your deadlines.

Be relentless—exceed expectations.

Be relentless—allow new ideas during your internal project reviews to enhance the project.

Be relentless—go the extra mile in editing to merge audio and video into a syncopated dance.

Be relentless—try to find and use new tools that will give your work extra impact. Plug-ins for editing systems, or enhanced lighting tools. Sliders and stabilizers for shooting, and taking the

extra time finding music that is perfect. Just no "close enough for government work."

One time, doing a company history for a major client, we had to show how their stores looked in the 1930s. We had pictures, but this was a video after all, and if we had moving footage it would please the client and add to the audience impact. I spent a night at home looking at all the public domain footage I could find. Finally, on the Internet Archive, I found a video about visual signage that had been produced in the early 1940s by a merchandising company trying to encourage more usage of electric signs and advertising billboards. There, I saw drive-through footage of various city main streets and the signage stores were using to advertise their brand (usually logos of the store name).

Lo and behold, I found two different incredibly clear shots of customers entering and exiting our client's stores in New York City, logos big as life.

I didn't tell the client; we just placed the shots within the 1930s section showing various storefronts and surprised him with the new footage.

"Where did you get THAT from? I've never seen it!"

He was happy; we were happy; the audience loved the video and we chalked up a major success.

Be relentless.

CHAPTER TEN
Presenting the Project

The Environment

The client is always right, so if they insist on reviewing the final project at their location, be as prepared as you can be to make the best of the situation.

DISPLAYS and CABLES

Some computers have HDMI out, some don't. You need to be ready for anything. Have adapters or cables that allow you to hook up to anything. If you're using a MacBook Pro, chances are you have a display/Thunderbolt port out. Apple makes three or four different types of adapters for this output, including converting to HDMI, VGA and even composite video. Less expensive clones of these adapter are available through Amazon and eBay. This way you should be ready to mate up with any projector or display.

AUDIO

THE VIDEOBIZ

Some facilities have fabulous video projection and audio waiting for your use; others have a mixed bag. No matter what the size of the screen, you should be ready with your own augmented audio via a pair of wired or wireless speakers. Assuming you're showing the project to one to five people, a pair of enhanced computer speakers from a company like Logitech will do. If it's a larger crowd, you will have to up the ante. Two speakers are a must, especially if your mix is in stereo. Make no mistake; sound can mean the whole ball game.

YOUR PLACE

If it's your place the project is being shown, you need the best equipment you can muster. Luckily, large screen HD and even 4K displays are very affordable. Pay special attention to the scan rate—you really need 120 MHz or above for the video to look smooth. You can send the audio out through the audio outputs on your computer, or if you're using HDMI you can run audio out from the display, which often has both optical and analog outputs for speakers.

Making Revisions

Just assume there will be revisions and practice your smile.

If text or animation is the problem, no big deal. Maybe it's their fault, may it's yours (artists often misspell things so double check their work). Making the changes often requires just a few keystrokes.

If the changes involve footage, the issue will be whether or not you have a satisfactory replacement in what you shot. If so, the change is no big deal. If you do not have a replacement and it is a shot you simply didn't get that was on the shot list, you'll have to offer a solution. If the change is client error—i.e., the logo changed, someone in the video was fired and can't be shown, etc., then you should talk privately with your direct contact about paying for a half-day reshoot. A lot of this decision-making comes down to your relationship with your client.

THE VIDEOBIZ

Make the changes, then re-present the project to the direct client.

Finally, get a sign-off that the project meets spec and both the client and you can "Sign Off."

Distribution?

Many projects are prepared for special events, like major meetings, retirement parties, reunions or annual meetings.

But some require mass distribution via the web, DVD, thumb drive, etc. This can be a short run of copies, or a massive run if it's a large corporation.

DVDs are a bit of work. They may require jackets with printed information, color printing on the DVD and of course DVD duplication.

If you're in the home market, this can be an area of additional profit for you. I have a client from 20 years ago that I still make 20 copies a year for. It was a PBS program featuring my client and fellow explorers. He uses them as gifts for his geophysical firm.

THE VIDEOBIZ

But if someone requires 50 to 5000 copies or more, this can be a bit of work. You need to find a DVD duplicator who will charge you a reasonable price that you can mark up before reselling to your client. In these size numbers, the client may have duplication suppliers anyway and will just ask you for a copy of the master DVD. In that case you do not have the responsibility of quality control, so there are tradeoffs to be considered.

Web distribution is a bit more complicated, but there are services such as Vimeo that can be set up with passwords for end clients to access. In this case, you would charge a modest monthly fee for digitizing and hosting the project.

YOUR BUSINESS MATURES

CHAPTER ELEVEN
Basic Business

Making Money

Your job in the end is to make enough money so that making videos becomes a full-time job. To do this, you simply must spend less money than you receive from your jobs. This can be more difficult than you think.

First thing is to open a new bank account for your business once you sell a job, or if you are putting some money (capital) into the business. You will probably have to be registered with your state and have a tax ID number (or your Social Security number) to open the account. *This is not professional advice, so check your local laws and ask what the bank requires. It's different for each state.*

There are three areas to consider when trying to make money:

Income from job
 Expenses from job
 Daily operating expenses

THE VIDEOBIZ

This comes naturally to some people; to others it's a foreign language. But the real basics are to maximize income and minimize costs.

In the beginning this should be relatively easy, even if you have to give a little to do your first job. Time and materials (tape, digital storage, props, stock footage fees, announcer fees, music library fees) whether it's your time or someone else's, adds up to income.

Costs of the job, including subcontractors, materials, equipment rentals and those other things listed above—anything that is spent directly on a job—is your expense. The trick is to mark up all your pass-through expenses. Money costs money, and markups are a fair way of compensating you for the cost of providing these materials and waiting to be reimbursed. Everyone marks up— Amazon pays less for that camera you bought than you paid Amazon. Restaurants must mark up their raw costs and kitchen staff payroll to arrive at a profitable price per meal.

The third area is the killer. The cost of operating your business itself will sneak up on you. Depending on the kind of business entity you choose to operate as (sole proprietor, LLC, S corporation, partnership, regular corporation) you will have a myriad of expenses. Telephone, stationary, rent, insurance and any outside help you need to run the business (accountant, lawyer, consultant) can really add up.

A note on rent: you can't fire rent. Once you sign a lease, you're stuck. So think very carefully about the commitment you're making. Rent below your perceived means. The biggest ongoing problem I had in business was the monthly cost of rent. We live in a

cyber world and it's easy to do ongoing business over the phone or via instant messenger. It's not easy to get out of a lease. If you like being around other people (tough for a writer, but not as tough for a shooter) think about coworking facilities. When you get to a certain size, it may be necessary to have a presence. That's something only you can decide, based on your market.

My uncle was a well-known market researcher for magazines and newspapers most of his career. When he bought a house, he outfitted the basement into a space that could accommodate twelve temporary coworkers. He was smart.

If you hire people on a permanent basis there will be Social Security withholding, payroll taxes and, with any luck, income tax.

This is why you need to charge real money to pay for your time, job expenses and continuing overhead.

There are excellent books available to explain this all to you. Here's one I like that covers issues we're discussing in this chapter:

Starting A Business All-in-One for Dummies, available at Amazon and local book retailers.

The above book covers all legal and financial aspects of starting a business and keeps it basic enough so that even I can understand it.

One more issue we have to discuss: solvency, or cash flow.

Another reason for markups and fair hourly rates is to provide you the cash you need to operate smoothly. Profit is one thing, but you can be profitable and not have enough cash to operate!

This is one reason you should insist on a startup payment and progress payments as we previously discussed. But some companies will insist on "net 30," which means you do not have their money to operate on for at least 30 days.

If you're independently wealthy, you just put capital into your business either as a startup investment or as a loan to the company. This assumes you've chosen a business type and registered with the state and the IRS. If not, you pull money out of your personal account and put it into your business account.

Having enough cash flow means your suppliers are paid on time, you can pay for your rentals and materials and maybe you can even start to pay yourself.

Once again, these are my opinions and are based only on my experience and not current research. There are other books that cover the accounting aspects of running a business, and as soon as you're handling more than one job at a time it's time to think about hiring an accountant.

Staying Legal

This will be short and bitter.

There will be paperwork, perhaps lots of it, as you grow to be more successful.

You need to comply with local business laws, even if you're operating as a sole proprietor.

You need to report your income to the IRS, either on your personal tax form or on a business tax form if you have chosen a more complicated business entity.

You will need an accountant—preferably a certified public accountant—and you will need legal advice. As we said previously, dealing with your state and the IRS requires filling out forms, paying registration fees and more as you grow. At some point, an office manager may become part of your operating expense.

I know people operating in the video industry who to this day operate as sole proprietors, have no employees and are very successful. They simply want to minimize operating expenses, work out of their home and provide a good service to a few customers at a time. How you operate must consider your vision for the next ten years.

My partner and I started doing **none** of this and because **we hadn't chosen a business entity**, we ended up owing $5000 each on our personal income taxes the first year we made money. Yes, we had a business checkbook, but as a simple partnership any profits or losses accrued to our personal tax liabilities. On the other hand, just eight years later we were operating as a C corporation, had 17 employees and were doing a million dollars plus per year. And we were profitable.

Recommended: **Legal Guide for Starting & Running a Small Business** by Fred S. Steingold, available on Amazon in both print and Kindle formats.

CHAPTER TWELVE
Managing Growth

Growing Through Innovation

Traditional business wisdom is that if your company isn't growing, your company is dying.

On the face of it, you might say, "Huh? What? Why?"

But it's a fact. Capitalism is based on growth. Apple started in a garage. So did HP. My business started in a one-bedroom apartment on Milwaukee's east side. All of these businesses grew. (Okay, Apple and HP did better than I did!)

There are many ways to grow. All of them involve reinvesting your profits back into the company.

Part of the game is investing the right amount without draining your coffers. As your balance sheet grows, loans or leases are possible, especially for equipment.

So, let's start there.

Offering new technology often can result in more sales. One producer I know got into high-def early, then 4K before 4K became big. This allowed him to take a USP based on his knowledge of technology and let him raise his rates for these higher-definition images. Since the result was visibly better and could be projected as high-def at meetings, it helped him get into big meetings as well. One smart move made a five-year growth difference for that entrepreneur.

Another way to innovate is to attach yourself to new trends in visual storytelling. In 2011, we moved into time-lapse storytelling, using time-lapse videography (recorded sequential stills over a period of days, weeks or months) as the basis for recording the rebuild of a retail space, and integrated regular videography at various speeds as well. This was integrated into a story of the development of the location, interviews with principals and videography of the opening.

We didn't have to buy special equipment. We rented it and mounted it in semi-permanent locations throughout the new facility.

These were major six-figure projects and we did three more of them in the next few years, across the country from New York City to San Francisco.

To add to the arsenal and keep the projects fresh, we added drone flyovers during one of the projects, capitalizing on a trend that was just emerging.

THE VIDEOBIZ

Both time-lapse and drone video are just regular tools now, but they kept us growing and profitable for four years.

Growing Through Productivity

As a business owner, I believed in keeping up with the technology and software tools that were part and parcel of our work. The reason was simple. I had to assign and judge the work of employees and freelancers, so I didn't want anyone pulling the wool over my eyes when it came to time estimates or when I heard, "That can't be done!"

But just because I can do it all to some extent, doesn't mean I should do it all. If I do it all, I'm limiting the number of projects I can do in a year. So at some point you have to increase your productivity through the purchase of better, faster equipment, and/or adding employees or regular freelancers.

This calls for a financial examination of how much profit an employee would add to your bottom line vs. the cost of the employee. The cost of the employee includes his or her base salary, payroll taxes and Social Security that has to be withheld and paid to

the government, and the space and equipment you need to add to accommodate the employee.

Another approach is to develop a relationship with freelance experts and work out a discounted cost because you are promising regular work. Freelancers are paid their hourly rate and handle their own taxes, Social Security, health care, etc. This is a popular way to go but stay up on IRS rules because the IRS doesn't like to think you are avoiding payroll taxes by having a full-time relationship with a freelancer. (I am not an accountant or lawyer and you need to retain them in order to keep your business running clean.)

Hire A Salesperson?

While we have discussed this earlier, let's look at it again based on what we know now.

We know:

You have to grow.

There are various ways to grow.

But the simplest way to grow is to develop more income, and that involves selling.

You may be a sales type, or you may not be a sales type. But either way, you only have so much time to run the company and produce work.

THE VIDEOBIZ

There are two kinds of salespeople for this discussion: lead-finders and turnkey sales people.

I have found that turnkey sales people are very hard to find. They don't know the subtleties of your business and are going to have a hard time handling objections without you being there. I found with even excellent salespeople, I had to write the proposal and deliver it in order to close the sale.

The most effective sales type for me was the lead-finder. Lead finders work from your mailing list or a directory of corporate executives. They call and call and call, finding the right person for their pitch. They pitch the generalities about video production and the excellence that your firm represents. They paint word pictures about the success the potential buyer could have professionally if they produce videos that are guaranteed to work. They direct the customer to your online samples or offer to come in and make a presentation. If there is an actual project in the offing, they attempt to set a date for a personal meeting with you to develop a proposal.

This is a numbers game, and requires a great deal of preparation and rehearsal. But if it works, it can make a major difference in your bottom line.

My deal with lead-finders was to pay them a small hourly wage and a percentage of the total sale. What these numbers are is your decision.

CHAPTER THIRTEEN
Ups and Downs

Failure Is an Option

Some things don't go right. The client thought you were using pictures of Uncle Charlie, but you didn't include them. The client said to incorporate their meeting theme, "Go, Go MegaCorp," into the script, but you didn't find a place to put it that didn't seem artificial. You misspelled the chairman of the board's name. You made a joke during your pitch and it offended someone. These are small examples, but I've been through bigger.

The fact is, these are learning opportunities. They help you hone the rough edges of your future relationships or creative strategies, and it all adds up. They say it takes 10,000 hours of work on your area of specialization to be considered an expert and for you to breeze effortlessly through what you do for a living. That doesn't mean 10,000 PERFECT hours. You learn from successes and failures, and you can expect failures, small or spectacular. All you have to do is modify your approach when things go bad, and you've improved your capabilities and future stature.

Brien Lee

In the words of Douglas Adams, "Don't panic."

Bouncing Back

It has been said that it takes 10,000 hours to truly be a master at your craft. Within that 10,000 hours will be a spectacular failure. A client just doesn't like the end result or, even worse, doesn't like you. A live-stage event goes bad when an actor forgets his lines. A client asks you to take your producer coworker off an account because they've lost faith in the person. In many cases, you make adjustments and move on. But in others, a relationship is permanently damaged.

You're crushed, depressed, angry.

Get over it. This reaction won't help you or the people you work with. You're the leader; lead. You make changes and bounce back. There is no other option. To remain negative in the face of adversity is a career killer. All you can do is learn from the failure, adjust your approach, and move on to the next job.

And there always is a next job, as long as you're always looking for the next job!

I've been there. I apologized, even when the client wanted to end the relationship and move on. Believe it or not, there are better days ahead!

"True Confessions": Mistakes Galore

AVL Videowall

AVL (Audio Visual Laboratories) was the major manufacturer of slide projector control equipment. It allowed for controlling 9, 15, 21 or more slide projectors to be projected on a big screen timed precisely to a soundtrack. The results were spectacular. True dissolves. Cascading effects. A soundtrack that could be in stereo, quad and purely high-definition because it was coming off of audio tape, as opposed to a scratchy optical track like in the industrial films of the time.

And I had the AVL account. We did most of their demo shows, displaying the capabilities of their latest products, which automatically made us an elite producer within the industry.

But I had overreached. Our first success with AVL was when I was in my original partnership with an excellent photographer and AVL programmer (making the AVL do all those cool effects I described).

THE VIDEOBIZ

But we had split up. Long story. I was on my own and since I retained the AVL account after the split, I was feeling my oats. I had a full staff, but we were writers and directors, not AVL experts.

But I soldiered on and designed a screen array that I thought would be spectacular. A solid back wall into which would be placed 21 different small rear screens, with a major center screen for video rolls or major speaker support slides.

I looked at the ballroom dimensions on paper and spec'd out the screens and hard wall backdrop.

I hired a staging company to build the stage, backdrop and screens, kept track of how they were doing and proceeded to produce the extravaganza.

Finally, the show date neared, and we proceeded to the hotel to be there for set-up and rehearse.

After drinks with the client I proceeded to the ballroom to see what I had wrought.

I had wrought a disaster.

The stage projected halfway into the room, leaving the audience way too close to the screens. No one in any audience seat would be able to see the whole stage. The projector throws were longer than I anticipated, and in order for the mini-screens to be filled by the projection image, the stage had to be pushed out into the room significantly.

I hadn't seen the ballroom before the event. Further, I left the choice of lenses to the staging company, and they chose what they had in stock. Had we done our homework we could have used wider-angle lenses, cutting how far the stage needed to jut out into the room.

The show ran fine but was uncomfortable to watch. There was a saving grace: I had produced a humorous take-off on a TV show of the time, *Hill Street Blues*, in video. It opened on a shot similar to the real show's opening sequence, a garage door opening up. But instead of police cars zooming out, a warehouse worker took an AVL box and tossed it toward the camera. This was the start of 10 to 15 humorous vignettes featuring all the major players at AVL who were well-known in the industry. It was a hit and mitigated the staging disaster that preceded it.

I was lucky I didn't lose the account, but I learned a valuable lesson: do the major homework involved in projection and staging, and never again underestimate that part of the business.

The Milwaukee Journal

I produced videos and meetings for the *Milwaukee Journal* for nearly 15 years. It was a fabulous relationship. It had started with us producing a market presentation about the paper's advertising possibilities that was presented to Milwaukee's advertising community. It was so successful we took it on the road to New York, Chicago and San Francisco, something we repeated every other year for 13 years. During that time, we produced other slide shows and videos that detailed new advertising opportunities like a new magazine section, new ad programs and specials and even a videotape touting Milwaukee as a market to major ad agencies nationwide.

But in the fifteenth year, we were asked to produce an overview video touting new sections the paper was unveiling. At that same time, we were beta-testing a new piece of video equipment that helped create graphics and "image floats" across the screen. So we tried to kill two birds with one stone. Instead we killed the account.

Working with the equipment was a pain, and our designated editor on the project didn't like the equipment and didn't like working overtime. Progress was slow. Deadline promises were made and missed. I kept on the editor as well as the manufacturer of the equipment to improve the software, but the final deadline was upon us and we had only completed one-third of the videotape.

It wasn't a big budget video, but the account was in the balance. The right solution would have been to abandon the equipment, get an edit done and bring that edit to a post-production house that could have added the effects in an (expensive) afternoon. But because it was small budget, I didn't do that. We never worked with the client again.

Regrets, I have a few.

Enerpac

Okay, here's one with a twist.

Remember my discussion of honesty in selling situations?

Here's a case where it worked to my advantage.

My partner and I were pitching a company that made hydraulic valves that powered everything from lift trucks to garbage trucks. They called us up out of the blue to come in and review their need for an "image" video—an overview of the company, its USP and its products.

When we arrived, we were met by the president of the company. We were ready to show our work, but he interrupted us.

"I have something I want you to see first," he said.

"Okay," we said.

He then rolled tape on a beautiful but kind of pointless 15 minutes of beautiful art, Leonardo da Vinci allusions and rather reverent music.

When it was over, he asked "What do you think?"

My partner, who usually took the lead, said, "Well, it was very artful . . . er, nice."

This led to a short hemming and hawing session as the two danced around the obvious. Finally, I could take it no more.

"That video was a waste of talent," I said.

"Yes!", screamed the president.

The video we were shown was a product of the internal marketing director, who had gone to Mexico City to have it produced—or overproduced—and under-messaged.

We got the job.

CHAPTER FOURTEEN
Final Facts About Work and Life

The Work/Life Balance

Owning your own business has its challenges. The drain on your personal or family time is the toughest one.

We've spent a lot of time talking about the necessity of being devoted to your clients and their results.

But how to do this without impacting your family life?

You need to set rules, and each of us will respond to rules that are tailored to us.

One owner I know had a strict policy about work hours being 8:00 a.m. to 5:30 p.m. That was it. This worked for him based on the nature of his work—mostly training tapes written by the clients. He still responded to emergencies but would often delegate that response to coworkers.

Another producer I know insisted on regular vacations. Not staycations; she traveled to the warmest climates and nicest beaches around the world. She worked hard in her business but set up her own rule—two three-week vacations a year, period.

There will come a time when you're asked to miss a Christmas, birthday, anniversary, piano recital or soccer championship. And unless you're fully staffed, you may simply have to go to work. Find a way to make it up to your family with a special event or gift and try to avoid the conflict in the future.

Develop your own method to keep things in balance and you will not fall into the trap of resenting your clients.

There are other things you can do to help your client relationships—and some things you **shouldn't** do!

The Care and Handling of Clients

The service level you provide and the care you show during production is your ticket to earning repeat business. In this age of the "Blame Game" these five tips will help you overcome pitfalls that might sink your competition.

1. Insist on a client of one.

Larger corporations (or cash- and staff-laden startups) will often want you to work with a committee. Unless you've added 40 hours to your quote to referee their bouts of indecision, what you want is a good one-on-one relationship with the representative of that group, usually the person who hired you. You should happily attend one or two committee meetings for input (usually before the script is written), but script reviews, edit reviews, update meetings, change of direction discussions, etc. should be handled by you and your direct client. He or she can and should synthesize input from the stakeholders, which means your contact will come to

understand the contradictions and turf-grabbing that often comes from these meetings and can present to you a unified front, something you aren't being paid to do. (As always, there are exceptions.)

2. **Put it on paper. Paper's obsolete? Put it in an email.**

Let's start with the proposal. This is the critical document where you describe what you will do, for what amount of money, delivered on what schedule. It is the place where you describe how you work, how projects are reviewed, what your pay schedule is, what happens in the case of cancellations or change orders and, most importantly, what expectations should be met. In many cases you may deliver within an outline of the project or projects, or at least a couple of paragraphs of creative description. The easier it is for the client to understand and visualize the deliverable, the more likely it is you will be the producer selected. Throughout the life of the project you should write up progress reports—short descriptions of your activities, your needs (access to locations, as an example) and any calendar or budget updates.

3. **Show up.**

I had a client many, many years ago that I grew to hate. He/she was a real screamer, who motivated by fear. This was a big, prized account and we had a lot of deliverables for a big trade show: interactive kiosks, a major multimedia meeting show and more. We delivered all of these on time and they were pretty nifty. The show traveled well, the trade show was a success and that was that. But the client had worn me out and totally demotivated me through bad attitude and poor interpersonal skills. There was one show left, at company HQ, where the client would take a victory lap. The big

multimedia show would be shown to the assembled masses—the internal people who had worked laboriously (under the threat of verbal abuse) to make the project a success. It was expected that I would be there to show the show. But I was a writer/director, not the show's programmer. If something went wrong I couldn't fix it. Besides, it was Christmas week, I had a four-year-old at home, and I was running a company. At least those were my excuses. So I sent someone else. The show crashed (this was a 25-projector show). The end. **Of the relationship.**

4. Report problems.

There will be problems. In a project where you are expecting the client to provide critical materials (logos, photos, interviews with execs, etc.), there will be hangups. Sometimes additional requests mean changes to the budget. CLIENTS DON'T LIKE SURPRISES. This is a case where the one-on-one rule will help you. Reporting a problem to a committee often results in finger-pointing and inaction. But by having a single person whose career path is on the line depending on the success or failure of this project, you will get results when you need them.

5. Celebrate success and do a postmortem.

Once the project meets its audience, it's time for a postmortem. A postmortem is a newspaper term that means to review what went right and what went wrong. In video production terms it may mean a party, a celebratory drink and talk or a formal review of what went right and wrong. These can be happy events or a bit more trying, but they are necessary to your long-term relationship. If you screwed up in some way, admit it. If you start pointing fingers at

others, the relationship is over. And there is nothing more valuable in business than solid long-term relationships.

How to Screw Up Your Reputation

In any business, all you have is your reputation. Word-of-mouth works in a ten-to-one ratio—for every one good mention, you'll get ten bad mentions. Here are ways to earn yourself some BAD mentions.

5. Don't understand your client's needs.

This is not to be confused with "end client" needs. The end client is the person or group your client represents. Let's say the person you're working with works in an in-house communications department. He answers to the head of PR. You know the head of PR wants a great "Welcome to Corpco" company overview. You've done your research and you know the points to be covered.

But your direct client—the guy in the communications or video department—has his own needs. Call them turn-ons. He may define a great video as one with slo-mo emotive pictures of faces, or fast paced aerial flyovers. He likes smokey-voiced female announcers. Well, as long as these don't conflict with your vision or budget, you're a fool not to include them as best you can.

Also remember the client's unspoken needs: survival, promotions, bonuses and the corner office. (See the last article.)

4. Don't communicate.

Clients don't like surprises. If production dates are slipping because of late delivery of materials or approvals, you need to have the guts to tell your client. If it's your fault, even more so.

3. Don't show up.

I had a client many, many years ago that I grew to hate. He/she was a real screamer, who motivated by fear.

This was a big, prized account and we had a lot of deliverables for a big trade show: interactive kiosks, a major multimedia meeting show, and more. We delivered all of these on time and they were nifty. The show traveled well, the trade show was a success and that was that.

But the client had worn me out and totally demotivated me through bad attitude and poor interpersonal skills.

There was one show left, at company HQ, where the client would take a victory lap. The big multimedia show would be shown to the assembled masses—the internal people who had worked

laboriously (under the threat of verbal abuse) to make the project a success. It was expected that I would be there to show the show. But I was a writer/director, not the show's programmer. If something went wrong I couldn't fix it. Besides, it was Christmas week, I had a four-year-old at home, and I was running a company. At least those were my excuses. So I sent the guy who had traveled with the show instead.

The show crashed and no one could fix it.

Had I been there, I couldn't have fixed it either. But that didn't matter. I wasn't there, that was insulting to the client, and therefore it was all my fault.

And it was. For the money we had received, and despite the aggravation, I should have been there.

Always show up.

2. Don't meet deadlines.

The key word is *dead*. You're dead if you don't, and so is the client. See point 1

1. Don't give it your all.

If you or someone on your team says, "Close enough for government work," fire yourself or them.

Producing video for major and emerging companies is a privilege, and one that's harder and harder to obtain. Exceed your own expectations, surprise (positively) the client and you'll get hired

again. Yes, it will take sleepless nights, Red Bull, coffee, junk food and sugar (well, maybe), but you will stay in business and that's something in itself.

There are plenty of other things not to do, and you will learn them by doing them, once. This is a case where "lather, rinse, repeat" **doesn't** help.

You're Only as Good as Your Last Job (or Award)

It's sad, but true.

Time flies, and that triumph you produced for MegaCorp is suddenly two or three years old. Potential clients want to know you're active, so make sure your website is updated with your latest projects or a sample reel featuring only projects from the last year.

Update your email list with a roundup of your most recent productions and any news your company has (new equipment, new capabilities, new people, new awards). We used to do this via regular mail in the eighties and it brought in a number of surprise jobs from new clients. The same was later true for our website and email lists.

If you can afford it, strategically enter some awards competitions you feel might respond well to your work. There are many major industrial and home market festivals such as the CINDYs, the

ADDYs, The New York Festival, the Communicator Awards, IABC and many others. If you are a subject matter expert, there might be industry-specific festivals you can enter as well to reach more potential customers in your target industry.

And, as we said before, club your way up. Join local organizations, service clubs, charitable organizations, arts groups. Somewhere along the way someone will ask you to help out with a campaign. Once you do, they'll feel they owe you—and will respond by considering you for a "real" project.

SUPPLEMENTAL MATERIALS

Sample Proposal

**Project Proposal
Prepared for:
Milwaukee Electric Tool Company
Brookfield, Wisconsin
April 2, 2002**

Introduction

Milwaukee Electric Tool Company, a division of Atlas-Copco, is a leading electric power tool manufacturer and the only tool manufacturer in the United States focusing solely on the professional marketplace.

In 1997, with the help of Brien Lee Creative Solutions, Milwaukee Electric Tool released a corporate image video entitled "The Test of Time." This video told the Milwaukee Electric Tool story up to that

point, with an emphasis on the company's history and heritage. Now, in a new millennium, and approaching its eightieth birthday, it is time for a new dynamic Milwaukee Tool story, one that emphasizes its unique market appeal, product and people strengths and the brand strengths inherent in the Milwaukee name.

In this proposal we will recommend a creative approach to this story, some presentation options, present a design concept and offer a working budget and production schedule.

Background

Founded in 1924 by A.F. Siebert with the release of the ingenious "Hole Shooter," Milwaukee Electric Tool Company has offered innovations in portable, professional power for the professional. In targeting the professional trades, Milwaukee centers its marketing and products around those who make a living building and maintaining: plumbers, carpenters, construction workers, remodelers, cabinet-makers, electricians, etc.

The company is an inventor, innovator, and partner for these professionals, creating heavy-duty tools—more than 400 models of drills, Sawzalls, circular saws, finder and hammers and more than 2500 accessories.

But products are only part of the story. Milwaukee Electric Tool is also a partner to the professional. The company listens to product needs and responds. It offers comprehensive training classes and media to make the industry and the professional more productive, and it takes advantage of the communications tools of the day, from print to the web to video, to reach out to its users with

information, training and insight that help users further their investment through the proper and efficient use of these tools and accessories.

The Milwaukee Story for 2002, then, must be a reflection of the Milwaukee Tool of Today and Tomorrow. This is a company which understands the holistic nature of its product—more than hardware, or a handheld tool, it is in fact a system of productivity based on innovative design, two-way communications with the trades, and ongoing education of the user and the marketplace. Milwaukee Tool is, in fact, a leader—and acts like one. From its commitment to quality and innovation, to its belief in team-building and community support, Milwaukee never forgets it professional roots, or the power its people bring to the "World of Power" its products provide for professionals.

Goals

The goal of this presentation is simple: to position Milwaukee Electric Tool Company as the single choice in portable electric power tools for the professional. In this sense, we will position Milwaukee Electric Tool not just as a manufacturer, but as a partner to the profession, offering a multi-tiered approach to making users more productive, profitable, and powerful professionals through the wide range of solutions and insight Milwaukee offers them.

The production values in this presentation must be very high-end, complementing the stories of innovation and engineering excellence we will detail.

We will reflect on Milwaukee's heritage, but unlike "Test of Time," this will be a forward-looking piece, both visually and in content.

THE VIDEOBIZ

Medium

The production medium will be digital video, with an emphasis on 3-D and composited techniques. BLCS will create all materials as updatable QuickTime files for later manipulation and updating by Milwaukee Electric Tool's training department.

The length will be approximately six to seven minutes—a very compact, high-energy and densely produced story.

While it is assumed that this will be a linear story delivered primarily as a videotape, we are also recommending that a menu-driven CD-ROM be delivered as well, so that specific areas of the Milwaukee Story can be accessed by the presenter or by a viewer. This will require a simple elegant menu-driven selection, bootable from CD-ROM and playable on any laptop.

To that end, BLCS will also deliver a compressed MPEG-2 file of the video for playback on any computer, and will also provide a Windows Media streaming file of the video for use on websites or for emailing to potential customers.

Creative Approach

Milwaukee Electric Tool has a number of themes it uses in its advertising and marketing, from "Nothing but Heavy Duty" to "Professionals Serving Professionals." But a slightly broader, more encompassing approach is required here. We will be appealing to professionals, distributors and even do-it-yourselfers who want to take a professional approach to their home improvements. We will be telling a story of how Milwaukee does business, but we also must

tell a story of the impact Milwaukee has on the world—an even more compelling point in light of people's renewed focus on their homes and their workplaces following the tragedy of 9/11.

We recommend calling the piece:

"Milwaukee Electric Tool Company Professionals... Building Tomorrow Together."

This encompasses the keyword "professionals," but also brings in the themes of teamwork, progress, construction and forward-looking hope, be it for a profession, a home, a business or a society. It plays to Milwaukee's strength as an educator, a toolmaker, a citizen and a team builder. And it stresses Milwaukee's commitment to the success of the individuals and companies who rely on Milwaukee's products, accessories and advice.

It is an emotional appeal, and one only Milwaukee can lay claim to. Milwaukee is the one company that takes a purely professional approach, engages in two-way dialogue, builds communities both real and virtual, and is dedicated to making a difference in many different ways.

Visual Approach

We recommend a sophisticated use of 3-D space to illustrate our concepts (see supplied samples). Milwaukee Tools starts with an idea. Home construction or improvement starts with an idea. These ideas are researched, brought to paper, visualized, tested and made real. By using a visual motif of 2-D design (al la blueprints), 3-D animation and, finally, real-space construction of reality, we make the point that Milwaukee is a key player in helping professionals

make their skills, their ideas, and their professions real—through the use of the right tools, designed to do the right job.

Each section of the video (or CD) will use this motif.

A key technique will be the use of ultimatted video of people using the tools moving in and out of the 2-D, 3-D and "real" environments. This will require special studio shooting which BLCS can accomplish at its studios.

Key Sections / Brief Outline

Premise: Building A Future Together

History/Innovation

Products

Markets/Partners

Professionals

Distributors

Enthusiasts/DIY

Manufacturing

Cellular manufacturing

ISO

Engineering/Design

Community

Online

Heavy Duty Club

Offline

Habitat for Humanity

911 response

Corporate Capers

Teams
 Quality

Training

Support

A Global Commitment—A World of Power

Atlas-Copco

Building Tomorrow

New Products

THE VIDEOBIZ

New Ideas

We Listen

We Design

We Build.... You build—together.

Closing Statement

Summary and appeal, information for follow-up

Items in Boldface represent menu items on the CD-ROM version

Production Team

Creative Director/Key Contact: Brien Lee

Writer: Amy Hansmann

Art Director/Animator: Eric Calcagnino

Programmer (Macromedia Director): Steve Tomczyk

Editor/ Additional Videography: Dan Ramsey

Production Manager: Denton Jones

Soundtrack Direction: Brien Lee

Production Schedule

Week 1, 2: Research, script

Week 3: Shotlists, breakdowns, graphic treatment samples for approval

Week 4-6: Videography

Week 4-8: Animations (wireframes and lo-res for approval), graphics (videography required for special effects and matting)

Week 8: Assemble all elements, stock footage, existing footage

Week 9: Soundtrack prep and music selection, narration

Week 10, 11: Online, animation rendering and assembly

Week 12: Final delivery

In Conclusion....

What Brien Lee Creative Solutions is proposing is a groundbreaking video and CD-ROM that will set the tone for Milwaukee Electric Tool Company for years to come. It will be a revolutionary statement of corporate ingenuity, commitment and community. It will be graphically unlike anything seen in the construction marketplace. We look forward to the opportunity to be your partner in this unique new communications statement.

THE VIDEOBIZ

Respectfully submitted,

Brien Lee
 President/ Creative Director

Enc: Why Brien Lee Creative Solutions
 Samples of Technique

Sample Quotation

The following is a view of a typical price quote sheet. These are usually made with Excel or Numbers on the Mac. The formula is simple—activity, hours, rate, and multiply hours by rate. Try to keep the quote in sections, to represent the various areas of activity—creative, shooting / materials acquisition, editing / audio. Subtotal and total. Require a down payment, progress payment, terms, and provide lines for signatures.

THE VIDEOBIZ

Cost Quotation
Bruno NYC Cab Rollout
4/16/09

Prepared for:

Bruno Independent Living Aids
Oconomowoc, Wisconsin

PROJECT SUMMARY:

Management and Creative
- Coordination
- Creative Direction
- Research for Distribution, Press Kits

Production
- Videography
- Talent
- Photography

Edit
- Product Loop
- VNR Materials
- VNR

Print
- Press Kit
- Postcard
- Reference Card
- Simple How-to Flyer
- Printing

Distribution Materials
- Magnets, Keychains, similar

Ground Crew
- Distribution

Management and Creative		Day	Rate	Line Item Total	
discounted, see below	Coordination and Management, Contact	15	$500.00	$7,500.00	
	Creative Direction and Scripts*	4	$500.00	$2,000.00	
	Direction*	1	$500.00	$500.00	
	Total, all Creative Development Elements				**$10,000.00**
Video Production— Main Video					
(web, DVD, electronic use, cab use, other variations, subject to refinement)	Art Direction	1	$640.00	$640.00	
	Site Producer	1	$640.00	$640.00	
	Audio Direction	0.5	$640.00	$320.00	
	Videography (crew of 2)	1.5	$1,200.00	$1,800.00	
	Soundtrack, Narration	1	$1,200.00	$1,200.00	
	Edit and Post, Graphics	2	$1,200.00	$2,400.00	
	Talent	2	$600.00	$1,200.00	
	Materials (tape stock, review copies, etc.)	4	$50.00	$200.00	
					$8,400.00
Video Production— VNR Materials					
	Onsite Videography	0.5	$1,200.00	$600.00	
	Edit	1	$1,200.00	$1,200.00	
	Talent	1	$1,000.00	$1,000.00	
	Materials (tape stock, review copies, etc.)	4	$50.00	$200.00	
					$3,000.00
Photography					
	Photographer	1	$1,200.00	$1,200.00	
	Proofs, Final Photoshop	1	$600.00	$600.00	
	Makeup	1	$500.00	$500.00	
	Craft Services for Video and Photography		$300.00	$300.00	
					$2,600.00
Distribution Materials					
	Stickers	500	$0.50	$250.00	
	Cards (quantity)	1000	$300.00	$300.00	
	Wallet Cards (quantity)	1000	$300.00	$300.00	
	Keychains (quantity)	250	$300.00	$300.00	
	Magnets (quantity)	500	$400.00	$400.00	
					$1,550.00
Ground Crew— Distribution and Fulfillment		5 people	5	$500.00	$2,500.00
					$2,500.00

Grand Total, All Items (Estimate, for planning purposes) **$28,050.00**

Respectfully Submitted,
Brien Lee VideoStory, Inc.

* Brien Lee's rates are discounted from the normal $800/day.

Billing will be separated into phases: VideoStory fees will be billed 66% retainer, then progress payments. Video Production and Photography will be pre-billed for 33.3 percent, given the immediacy of start-up. All other fees will be Net 15, unless supplier requires up front fees, in which case that will be billed as required.

Required to begin: **$9,665.67**

VideoStory will advise Bruno of any changes to this quote based on execution of a Change Order. It is advisable to set aside a 10% contingency in the event such changes become necessary.

_____ _____
for Brien Lee VideoStory, Inc. for Bruno Independent Living Aids

Sample Timeline

Production Schedule

Week 1, 2: Research, script

Week 3: Shotlists, breakdowns, graphic treatment samples for approval

Week 4-6: Videography

Week 4-8: Animations (wireframes and lo-res for approval), graphics (videography required for special effects and matting)

Week 8: Assemble all elements, stock footage, existing footage

Week 9: Soundtrack prep and music selection, narration

Week 10, 11: Online, animation rendering and assembly

Week 12: Final delivery.

THE VIDEOBIZ

A Gantt chart can visualize the production schedule both on a rolling calendar and a regular text timeline.

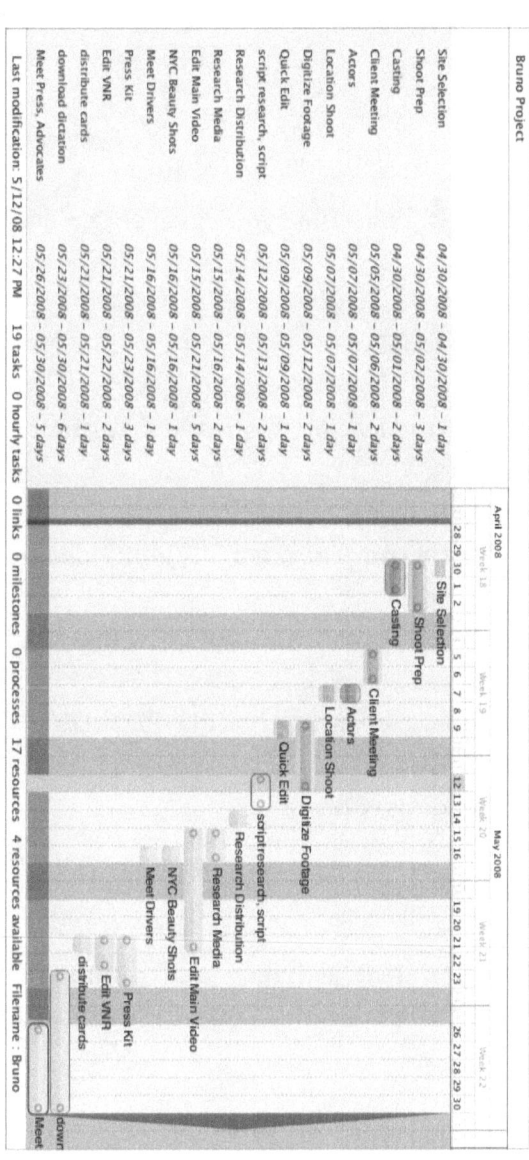

Video Info Links

Here is a list of web links that you can use for additional insight and information.

https://fb.me/thevideobiz

Facebook group for readers of this book. Questions, answers, tips, techniques and news.

https://www.payscale.com/research/US/Job=Videographer/Salary

A look at income levels for various types of video jobs.

https://www.youtube.com/watch?v=JqJTJPD2UDI

A discussion of wedding videos.

Http://www.amazon.com

The best place for fast delivery and comprehensive product offerings. Competitive prices. OEM offerings for batteries, chargers,

cables. Wide range of new and used camera equipment, protected by Amazon's return guarantee.

http://cheesycam.com/category/instagram/

A look at do-it-yourself techniques for making add-on gear for video cameras and audio, like stabilizers, lighting rigs, etc.

https://nofilmschool.com/

Although there is an emphasis on independent film (commercial), there are plenty of gear reviews and comparisons as well as discussions of story techniques.

https://www.creativecow.net/

News and discussion forums dedicated to the video production pro.

https://www.videomaker.com

One of the few remaining video production magazines directed at the "prosumer."

https://www.rogerdeakins.com/forums/

Video discussion forums.

https://forum.videohelp.com/

Forums of technical discussions about compressing video, making DVDs and other distribution issues.

https://www.videohelp.com/

The front page of Videohelp, with articles and reviews.

https://www.dpreview.com/

A home for users of DSLR cameras in video production.

https://thrivethemes.com/

If you're developing an online presence, you'll probably end up using WordPress. Thrive Themes makes a theme that is versatile and directed to the small business owner, with modules for collecting leads, creating training, direct mailing, marketing and many other aspects all necessary to sell yourself.

 https://filmlifestyle.com/filmmaker-forums/

More forums.

https://marketingland.com/library/channel/video-marketing

A discussion of the use of video on the internet with news of trends affecting streaming video.

https://www.videouniversity.com/

Founded online in 1997, this site offers comprehensive discussions and training on all things video.

https://www.facebook.com/tributetips/

THE VIDEOBIZ

For creators of tribute or commemorative videos, this Facebook group offers tips and discussion.

https://contently.net/

For freelancers of all stripes.

Stock Libraries

The following are libraries I have used. There are four types:

- *Free or Public Domain*
- *Paid by One Time Fee or Purchased Credits*
- *All You Can Eat*
- *Comprehensive (offers all types for one price)*

Free

Video

https://www.pond5.com
Incredible library of military and war footage.

https://www.videvo.net
Free, with searching to see if they have what you want. If they don't, they link you to Shutterstock, a paid library.

https://archive.org

A wealth of public domain footage, in a number of different libraries. Highly recommended: The Prelinger Archives, which features old tv, old industrial films, and other footage from which historical shots can be extracted to fill out a company history or tribute video.

Audio

jukedeck.com
Finished and editable music, free when you give credit or $.99

http://freemusicarchive.org/
Totally free music archive featuring new artists looking for exposure.

Photo

https://www.pexels.com/
Excellent free library for fill-in photos.

https://unsplash.com/
Great for dramatic photos of natural vistas, plus many other types of photos.

https://pixabay.com/
Offers free vector art, photos, video.

https://www.freepik.com/
Excellent source for illustrations and artwork. Offers many free files, but some require you to upgrade to a 9.99 / month fee to download "premium" files.

Paid by One Time Fee or Purchased Credits

Video

Shutterstock.com

A very good video library. We've completely meeting openers with their stock footage only. But you have to have a good budget—cuts range from $65 to $179 per clip, depending on resolution (SD, HD, or 4K)

https://www.pond5.com

A good library with a wide range of pricing depending on resolution. For instance, a clip of a plastic bottle floating under the ocean waterline ranges in price from $20-$100.

Audio

https://musicbakery.com/

Traditional "by the cut" music library, traditional cinematic music but very good.

https://audiojungle.net/

Part of the Envato Library, charges from $1 to $25 per cut.

APMmusic.com

The granddaddy of all music libraries, and priced more for corporate and Hollywood markets than the little guy, but worth knowing about. This was our main music source, and fees for corporate use ran anywhere from $70 / cut, to $200 / cut and up.

You won't know what the charge will be until you pick the music and fill out a form, or call "your representative" at APM. The fee depends on the use and venue.

Photo

https://depositphotos.com
Excellent photo library that offers a subscription plan for $29 / month, which as slows you 30 downloads / moth, with $1 per image if you exceed that.

All You Can Eat

Video

http://www.Videoblocks.com
$16.58 / month billed annually. Basic, decent library of stock elements, but often links to paid libraries when they don't have what you're looking for.

Audio

https://www.audioblocks.com
Music, sound effects for $12.41 /month billed annually. Decent music.

https://soundstripe.com/
An excellent all you can eat library for $135 / year. Good interface for selecting the type, meter, and orchestration you want. Plenty of rock, plenty of traditional

Photo

Storyblocks.com (click on "images" link upper left-hand corner)
$9/month billed annually. Good selection, but often links to paid libraries when they don't have what you're looking for.

Comprehensive (offers all kinds of files)

Envatoelements.com
Comprehensive library of Video, Photo, Illustration, Font, Audio, Animation, 3D and web elements. Flat monthly fee of $29-$33 / month. If you can afford it, this is an excellent way to go.

Storyblocks.com Unlimited Pro Video + Audio + Images
On this pricing page, note the **Unlimited Pro** option to the right, which combines Photo, Video, Audio libraries for 29.08 / month billed annually.

This listing just scratches the surface; a Google search for "Video Stock Footage", "Photo Library", or "Music Library" will get you dozens of additional listings which I have not used.

Samples and Case Histories

The following is a listing of pertinent video samples on our unlisted video site on YouTube. Clicking on the address below will bring you directly to the video you want to see.

For each video, there is a detailed case history provided in the information box below the video. **Be Sure to click on "Show More" for the complete story.**

Milwaukee Blood Center (Rebranding and Mission Statement)
https://youtu.be/KdTHWIyHcCI

Irvington High School Class of 1985 Reunion (Class Tribute)
https://youtu.be/vvtljrHyB-Q

Bel Brands Meeting Opener https://youtu.be/cgKCAF6h43o

Lemonade (HR/Training Oriented Humor)
https://youtu.be/f5Q9Jlb5EOw

Lyme Disease Information :30 Spot
https://youtu.be/nWafVlQnJ0s

American Cancer Society "Research Saves Lives"
https://youtu.be/O_MLqqvydLI

American Cancer Society Prevention Spot (30 Second Spot Promoting Preventive Cancer Care)
https://youtu.be/LCh5AnGahQA

The Milwaukee Rep at 50 (History Video with Interviews of Actors Directors, Patrons and Historical Video and Photos)
https://youtu.be/n3BMx2bmgHI

Walgreens Evanston Net Zero Store (Time Lapse Story of Building the first "Net Zero" Retail Facility in America)
https://youtu.be/uLU7WbG_S4E

As Far As You Want To Go (Recruiting Video / Human Resources)
https://youtu.be/NkwCQcH27Ho

Mercury: 50 Years of Leadership (Anniversary Video with Wealth of Historical Footage) https://youtu.be/zF8tewirbdM

Good Fortune: Milwaukee and China (English)
https://youtu.be/pxAtL-PlPZQ

UL 100 (100th Anniversary Meeting Opener)
https://youtu.be/NpRctanGFKk

Walgreens San Francisco (Time Lapse Story of Teardown and Rebuild of Store) https://youtu.be/VS9pnMRYYrg

THE VIDEOBIZ

There Goes My Baby (Original Music and Video Tracing Relationship of Family with Walgreens)
https://youtu.be/q4Ky6RDKtxc

Mr. & Mrs. Kern (Generac) (Tribute to Retiring Executive)
https://youtu.be/jlId5dJS0AI

An Evening with Mr. Cool (Combined Live and Video Meeting Opener) https://youtu.be/1hsbdFKqaQo

Walgreens: 100 Years in 100 Seconds (Meeting Opener)
https://youtu.be/r525c_daA3s

Bruno Independent Living Aids NYC Taxi Proposal (Product Solution)
 https://youtu.be/fM-qD_0JIRI

Matamoras Veterans Memorial Park (Tribute to the Veterans of Pike County, PA and Overview of Memorial)
https://youtu.be/_BWFvDkVNNY

Dr. Pill's Last Days (Humor— Outtakes)
https://youtu.be/qlfbAVLGPlM

Good Fortune (Mandarin Version) https://youtu.be/OoFBj47LLag

AFTERWORD

No two businesses are the same, and I've tried to cover practical topics that are common to a wide range of video businesses.

But even if you just plan to be a hobbyist, all this information will apply.

The examples I have discussed or shown are real. My business wasn't perfect, but we did have a sterling creative reputation. That kept us in business in various forms for 40 years.

I would have done some things differently, for sure. For instance, I wish I had a stronger financial partner/manager on board. This area is what caused me to lose my hair, and finally have a panic attack toward the end of my career. If you lose money for too long, or reinvest too liberally, you're bound to hit a snag.

On the other hand, being aware of trends and techniques allowed me to move the firm in the proper directions as we moved from one medium to another and stepped up our quality on an ongoing basis.

I enjoyed showing my work, addressing audiences, training employees and students and I generally loved what I did. My family was proud of me and I was proud of the coworkers, partners, suppliers, clients and financial institutions that stuck with me and

the company in good times and bad. And there were plenty of good times. I'm even proud of the people that split off and started their own businesses. Even more so now that we're no longer competitors!

Thank you for purchasing this book. In the supplemental materials you will find sample worksheets, proposals, budgets and more. You will also find supplemental links to videos I have produced as a companion to this book, as well as samples from my own career with attached war stories in the description.

Please give us a nice review if you liked our efforts here and follow us at Videobizbook.com and on Facebook on our VideoBizBook page (search for "Videobizbook").

Remember, be RELENTLESS!

Notes

About the Author:

Brien Lee created his first slide-sound show when he was 19, started a multi-media business when he was 23, started a video business when he was 33, and for the next 35 years wrote and produced videos, interactive exhibits, meetings, e-learning systems, original music, and more for a wide range of clients large and small, including AT&T, Generac, The American Cancer Society, Underwriters Labs, PSE&G, AT&T, Miller, Pabst, Schlitz, and many others.

He was born in New York City, spent his youth in New Jersey, and migrated to Milwaukee, Wisconsin to attend Marquette University. After that, he married his wife Barbara, started a business, became a father to his son Matt, and spent his working life writing and producing videos and other media. He returned to New Jersey to be closer to his relatives, enjoy New York City and the Jersey Shore, and to write.

© 2019 Brien Lee, All Rights Reserved
brienlee@videobizbook.com
www.videobizbook.com
VideoBizBook Facebook Page: VideoBizBook
Twitter: @VideoBizBook1
Instagram: videobizbook

www.ingramcontent.com/pod-product-compliance
Lightning Source LLC
Chambersburg PA
CBHW030630220526
45463CB00004B/1469